COMPILED BY WOODBINE HOUSE

A Room of Golden Shells

100 WORKS BY ARTISTS AND WRITERS WITH DOWN SYNDROME

WOODBINE HOUSE 2013

Cover art by Megan Bengtson.

Library of Congress Cataloging-in-Publication Data

A room of golden shells : 100 works by artists and writers with Down syndrome. — First edition.
 pages cm
 Includes bibliographical references (pages) and index.
 ISBN 978-1-60613-170-1
 1. Arts, American—21st century—Themes, motives. 2. Arts, Canadian—21st century—Themes, motives. 3. Down syndrome patients as artists—United States. 4. Down syndrome patients as artists—Canada. I. Woodbine House (Firm)
 NX504.2.R66 2013
 700.87′5—dc23
 2012048833

Manufactured in the United States of America

First edition
10 9 8 7 6 5 4 3 2 1

A Room of

GoldenShells

Creativity takes courage.

—*Henri Matisse*

TABLE OF CONTENTS

FIGURE ART

STILL LIFES

LANDSCAPES

OTHER MEDIA

Imagine stepping into a room full of golden shells. At first, your eyes might be dazzled by the brightness, so you might notice only that the shells are all the same color. On closer inspection, though, you would begin to notice differences. Some of the shells might be rosy or speckled or iridescent on the inside. Some might be slick to the touch; and others, knobby or corrugated. Some might be as heavy and solid as doorstops, while others might be as delicate and papery as a dragonfly's wings. And the riotous variety of shapes! Shells shaped like olives, needles, and fans; mittens, spirals, and doubloons; saucers, cones, and lions' paws. As you walked around the room, you would quickly realize that no two shells were really alike, despite sharing one salient feature.

So, what does a room of golden shells have to do with this collection of artwork and creative writing by teens and adults with Down syndrome?

Most obviously, the book is full of works that are dazzling in the best sense of the word as defined by Webster's New World dictionary—"arousing admiration by a brilliant display." Some of the works arouse our admiration because of the artist's or writer's creative pyrotechnics—their sheer mastery of their craft. Others captivate us because the creator's imagination has conjured up a whimsical or striking scene or a novel and thought-provoking turn of phrase. Still other works draw us in with their eye-catching use of colors or texture or their quiet revelations about how it feels to live with a disability.

The other reason this collection can be compared to a room of golden shells is this:

Although everyone who contributed to the book has one noteworthy attribute in common (Down syndrome), each contributor and his or her work is otherwise unique. Some of them, like fourteen-year-old Fiona Morris—who came up with the image of a room of golden shells—aspire to be professional writers or artists. Many pursue writing or art as a hobby while attending school, working, or volunteering. A few are award-winning artists who earn a living by selling their works. Their interests run the gamut from the artistic (theater, dance, music, photography) to the domestic (sewing, cooking, fashion, shopping); from the athletic (tennis, kayaking, swimming, horseback riding) to the sedentary (reading, watching TV and movies, playing video games); from the community-oriented (advocacy, public speaking, volunteering) to the outdoorsy (bird watching, collecting shells or leaves, gardening).

The contributors draw their inspiration from nature and from their travels; from popular culture and from artists and writers of the past; from friends and family and from their surroundings; from their faith and from their dreams. Their outlooks on life, as expressed through their art and writing, range from sunny to somber to everything in between. Clearly, their individual experiences, backgrounds, and personalities inform and color their writing and art. There is no such thing as "Down Syndrome Art" or "Down Syndrome Writing."

By publishing **A Room of Golden Shells,** Woodbine House hopes to draw attention to these two truths—first, that people with Down syndrome can be immensely talented artists and writers, and second, that individuals with Down syndrome defy categorization.

The creative talents of individual artists with Down syndrome are often on display at national Down syndrome conventions. Frequently, artists sit at tables in the exhibit hall, intently painting or drawing while family members sell completed art to awed convention-goers. But outside of the Down syndrome community and specialized art programs for individuals with disabilities such as VSA, there is much less recognition of the artistic abilities of people with Down syndrome. In fact, only one book featuring the work of an artist with Down syndrome has been commercially published in the United States—*The Eyes of Raymond Hu* (Brookline Books, 1999). True, in recent years, groups such as DOWNrightART have held a few exhibitions, and organizations such as Down Syndrome Footprint have held contests for artists with Down syndrome. But we still have a long way to go until children and adults with Down syndrome are routinely regarded as potential artists and provided with encouragement and opportunities to fan the creative spark that may burn within them.

If the artistic abilities of people with Down syndrome are underappreciated, there is even less recognition of their creative writing abilities. Indeed, because people with Down syndrome usually have delays in speech and language and may struggle with reading, the general perception is that people with Down syndrome are not very eloquent. In addition, research has shown that children and adults with Down syndrome tend to be visual learners, so it makes sense that more of them might be interested in creating pictures than in creating poetry or short stories.

Still, there have been scattered examples of people with Down syndrome who have a flair for creative writing. (The term creative writing is used here to refer primarily to poetry and fiction, rather than to nonfiction prose.) For example, Gretchen Josephson published a collection of poetry entitled *Bus Girl* in 1999, and Greg Palmer's book *Adventures in the Mainstream* includes some very respectable poems written by his son Ned. Inspired by these examples, we set out to see if there are other writers with Down syndrome who have something important to say and voices worth listening to—and we are delighted to report that there are. But these writers appear to be fewer and farther between than artists with Down syndrome. In our estimation, this means that the writers need, if anything, a brighter spotlight shone upon them so that the potential of other would-be writers with Down syndrome can be recognized and nurtured.

But why are we publishing a collection of writing and art and *labeling* it as containing works solely by people with Down syndrome if we want to make the point that people with Down syndrome defy categorization? After all, they are already pigeonholed more than almost any other group—as being "so happy – affectionate – slow - angelic – good at dancing – naïve - [fill in the stereotype]." The truth is, *grouping like things together sometimes makes their differences more apparent*. As you would do in a room full of golden shells, please take the time to recognize the differences. Really look at each work, read each contributor's biography, and appreciate the fact that individuals with Down syndrome are just that—*individuals*.

Although this collection highlights teens and adults with Down syndrome who are talented artists and writers, that, of course, does not mean that everyone with Down syndrome is good at art or writing! But we think it does mean that it is well worth looking beyond fine motor, language, or speech delays to see whether an individual with Down syndrome has the desire and motivation to be creative. And if he does, then it is imperative to nurture that creative impulse and help him overcome any barriers that stand in the way of expressing it.

How This Collection Was Assembled

The works published in *A Room of Golden Shells* were collected via a contest Woodbine House held from summer 2011 to late spring of 2012. The contest was open to residents of North America, ages twelve and up, who have a diagnosis of Down syndrome. Each contestant was allowed to submit up to three entries.

We publicized the contest through many channels—including on our website, on our Facebook page, in flyers at Down syndrome conventions, and in our print catalog; through the digital and print versions of the newsletter of the National Down Syndrome Congress, as well as through the publications and websites of many local Down syndrome groups and Arc chapters; through blogs and listservs of parents and professionals with a special interest in Down syndrome; on the About.com: Parenting Children with Special Needs website.

Staff at Woodbine House judged the approximately 200 entries received on the basis of creativity, originality, artistic merit, and overall impression. We also took into account whether the work gave us new insight into how people with Down syndrome perceive the world or their place in it.

Although the contest was widely publicized, there were undoubtedly many artists and writers with Down syndrome who did not hear about the contest, or who could not find someone to help them submit their works to us. And, unfortunately, we had to restrict the contest to North American residents due to logistics and costs. For this reason, we do not claim that the art and writing that appears in *A Room of Golden Shells* is "the best" that teenagers and adults with Down syndrome can do. But we do believe that all the work is more than worthy of being showcased in this book and that the collection as a whole offers a representative sample of the artistic and writing abilities of teenagers and adults with Down syndrome.

The works printed here came from contributors in twenty-one states and Canada. The artists and writers range in age from fourteen to their early fifties, but the majority are under thirty. Perhaps this is a reflection of the greater access to education in the arts and to community inclusion that younger people with Down syndrome have had since childhood, but it could also be because the younger contributors' parents were more likely to hear about the contest and help their children enter.

Contributors certified that the art or writing they submitted was their own work, or that they received only minimal help with mechanics such as firing ceramics, mixing colors, spelling, or typing. In preparing the writing for publication, we took pains not to "correct" or change the author's voice. We offered only the same types of editing we would to any other creative writer—querying them about spelling, punctuation, and paragraphing—but leaving their words and meaning unchanged.

THE BOTTOM LINE

If you are a person with Down syndrome, we hope that seeing the awesome art and writing in this book inspires you to find your own way of expressing what's on your mind and in your heart.

If you are a parent or teacher, we hope this collection spurs you on to provide the opportunities and support your child or student needs in order to hone his or her talents and ambitions—whatever they might be.

If you have no personal connection to Down syndrome, we hope this book broadens your view of the creative abilities of children and adults born with an extra twenty-first chromosome and gives you a glimpse of the kaleidoscopic range of their interests, concerns, and worldviews.

Finally, we hope that you enjoy what you see in *A Room of Golden Shells*—and then share the book with everyone you know who could benefit from looking at life from a different perspective.

Susan Stokes
Editor
Woodbine House

INTRODUCTION

*Joyce Wallace Scott**
with Dr. Gail Shafarman

When my twin sister, Judy, was born in 1943, her Down syndrome was still a condition with a terribly pejorative name and without a known cause. Our parents were told simply that she might be "a little slow," and advised to give her lots of love. Because of this wise advice from our caring family doctor, Judy and I were able to spend seven and a half years of an idyllic country childhood together, surrounded by a large family and loving community.

> *In our sand and earth world, Judy and I scratch and dig; we play with sticks and leaves, and with stones brought up from the creek. We make plates and cups from the green Catalpa leaves. We scrape designs in the sand, make stone soup and pour water into holes. Through handling our stones we discover a kind of counting, but, mainly, we discover the joy of sharing.*

At a time when infants with Down syndrome were routinely warehoused in state institutions soon after birth, we were indeed fortunate to grow up together. However, our parents were eventually pressured to accept the conventional wisdom of the time. At the urging of both their doctor and pastor, and told by authorities that she was impossibly retarded and unmanageable, they unwillingly sent Judy to live her life in a state institution.

My memories of that loss are as strong today as they were on the morning she left:
> *The sheet is cold—cold all the way to the edge. I stir, instinctively moving myself deeper into the bed seeking the warmth of my sister, my twin. For more than seven years, Judy and I have slept here cocooned together. We sleep like spoons, always small curved spoons, soft twin spoons, keeping each other close and warm. But now I feel cold—very cold. I reach my hand out across the bed to pull her close—reach further—and further still. She is not there beside me.*

What no one realized—either then or for the next thirty years—was that Judy was profoundly deaf and unable to hear the verbal testing that would condemn her and dictate the course of her life. I too did not understand.

> *Sometimes in my prayers, I pray that Judy speaks to me in real words. I often wonder why Judy never says any words I know. Her mouth sometimes opens and closes without a sound. Her eyes large and tender; Judy is like a goldfish that way. At other times her voice can be heard speaking not words, but soft strings of watery dove-like coos. These come from some almost forgotten time,*

* Author of the forthcoming memoir *EnTWINed: Secrets from the Silent World of Judith Scott,* from which the quotations in italics are taken.

long ago. The babbles, the sounds, are like a song she sings without knowing the words, a song with rhythm, with high and low notes, a conversation with the cadence of animated speech, hinting at intense topics of mutual concern. I pass to her my handmade leaf cup in our play yard, as she speaks her secret, maybe magical, words. I strain to hear the meaning in her mysterious language.

In my dreams, where my prayers have been answered, her sounds do turn into words that I can understand. In my dreams, we whisper and share our dolls' secrets. I'm sure it's just a matter of time now. Soon, with our quiet voices on, we will tell each other stories in the dark; our heads under the covers, our breath and our hair tangled into each other's.

The devastating impact of the decision to institutionalize Judy caused our mother to be hospitalized with a breakdown, and sent our father to an early death following a heart attack, brought on, I believe, by grief and guilt. It would take thirty-five years before Judy's story would begin to emerge from the shadows, from *"a state sponsored hell of dark rooms and high ceilings, a place of strange, invasive smells, and moaning bodies writhing on the floor."*

A Reunion and a Metamorphosis

In 1985, after many years of infrequent and heartbreaking trips from California back to Ohio to visit Judy in her bleak institution, I experienced a moment of epiphany during a week-long silent meditation.

For me, it is the hours of silence and meditation that allow everything to fall away, thoughts carried off like the dandelion heads Judy and I blew gently toward each other. . . .

And then gradually a strange lightness begins to fill my body, a lightness and a sense of joy. In the center of my heart I feel Judy and myself, the two of us still together, still one. I realize the absurdity of our separation and know with absolute certainty that it is no longer necessary, that it is possible for us to spend the rest of our lives together.

I suddenly came to understand that if I could become my sister's legal guardian, we could be reunited and share our lives together once more. The process was not an easy one, but eventually Judy came to live with us in Berkeley, California.

By good fortune, through a dear friend, I heard about Creative Growth, an art studio in nearby Oakland where artists with disabilities were provided with an environment in which they could give voice to their innate creativity. Upon visiting Creative Growth, I was immediately overcome by the joyful atmosphere I discovered there, and although Judy had never been known to show any interest or ability in art, I knew at once that this was where I would give anything for her to be.

For two years she produced nothing but seemingly random scribbles; but then, quite suddenly, Judy discovered a way to communicate with the world. . . . After almost two unengaged fallow years, Judy's time has finally arrived. Like the heroine in a fairytale, she suddenly awakens as from a long sleep and an amazing transformation takes place.

Judy, herself one of society's throwaways, now starts to weave found objects of all sorts, into creations that will be acclaimed for their exquisite beauty and complexity, truly transforming the straw of society's cast-offs into gold. . . . Her vision is surreal; breathtaking. The first time I saw Judy's work, a twin-like form tied with tender care, I knew that she too knew us as twins, together; two bodies joined as one.

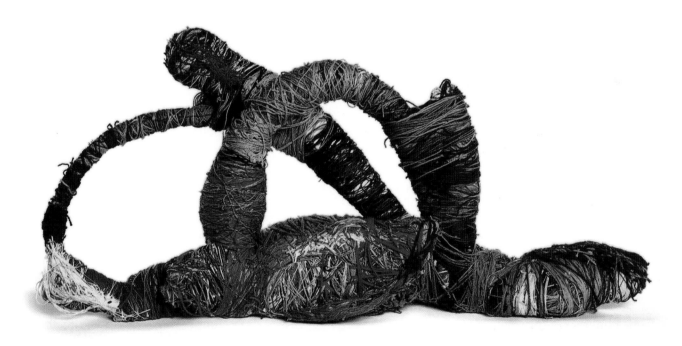

A fiber sculpture by Judith Scott

She spontaneously began to create the unique fiber sculptures for which she has since become famous. Judy, who throughout her life had lived in silence, with neither hearing nor speech, had suddenly acquired a voice and found a way to address the world, to tell her story and at last be heard. To what can this miracle be attributed?—for miracle it surely was. The answer must be "art."

THE POWER OF ART TO TRANSCEND DISABILITY

Art—and I include the art of creative writing as well as the graphic arts—provides a vehicle by which those who have limitations in articulating spoken language are finally able to express their inner selves; the feelings and thoughts that would otherwise remain trapped and hidden.

The creative and artistic forms of expression, for both the artist and others, besides being beautiful in and of themselves, also provide a window onto the inner self, providing cohesive forms of expression and awareness to the artist's private emotional landscape.

> *Reaction to Judy's sculptures can be emotional and profound. Benedetto Croce is one who has been touched by their magic. Deaf since birth, Benedetto is a museum director in Rome and an artist who shares the world of silence with Judy. As he watches a film of her at work, her hands lovingly caressing the threads as she weaves them to realize her inner vision, his eyes fill with tears. Seeing more than just the creation of a beautiful work of art, "She is," he says, "creating a soundless symphony, her hands plucking the threads she weaves like the strings of a silent harp."*

Through art it is possible to create a world that is neither limited nor defined by disability. It provides a means to hold one's own center, one's own independence—to be guided by one's inner voice, rather than be told by others what to do and when. Time and time again I have seen artists at Creative Growth stand taller and project who they are with confidence, because within these studio walls there is enormous respect for who they are, and for their artistic talents.

In describing the works of art in this volume, it is hard to capture their exuberance and joy, their originality of vision, and to convey the level of artistic excellence. Readers will be astonished by the brilliant use of colors, as well as the complex sense of pattern and design.

Tina Condic's *Cake*, for example, is striking in itself and reminiscent of Wayne Thiebaud's pop art in both its subject matter and its strong, bold use of reds and blues. Readers will also find the painting of her sister's wedding enchanting. Many pieces, which would be characterized as Folk Art or Outsider Art, use artistic

motifs, without traditional perspective, and employ imagination and humor in their themes and presentation. *Rockin' Party Fair* and *Party Taxi* by Emily Dodson illustrate this point by portraying both animals and people in a delightful, imaginative style.

Samantha Downing in *School Time* creates fish with beautiful designs and a background of rich color and pattern. This is an example of both abstract and realistic themes that are visually striking and filled with fantasy and imagination. Eliza Schaaf's painting of a dog is not only realistic but captures the essence of any middle-aged dog and "dogness." The yellow background sets off the piece perfectly. The landscapes of the Irish coast and of an Italian scene by Dylan Kuehl have an impressionistic quality. The artist gives the viewer a sense of depth and suggestion of nature, where the trees and flowers are hinted at through the evocative use of dark and light shades. Ashley Voss's *Dusk Over Peaceful Seas* creates a deep, emotional sense with bold horizontal strokes and gradations of color blending into purples, defining both sea and sky.

All the artists in this collection have found an effective way to communicate their vision to the world. This underlines the importance of developing programs to enable artists with disabilities to express themselves by providing an arena in which artistic expression trumps disability. These individuals need a place where the limitations perceived in the outside world no longer dominate. This makes it possible for those with Down syndrome to function freely, with a heightened sense of self-esteem. Such programs provide a place where they are respected and recognized as talented, as gifted; where they are no longer defined by their disability, a place in which to express inherent talents undisturbed and with total focus.

Much of the work created by artists at places like Creative Growth is considered to be "Outsider Art." What is meant by this term? Although a precise definition of Outsider Art has yet to find universal acceptance, in essence it is art produced in response to some inner creative urge by those who find themselves marginalized and who are on the fringes of society, those with no direct interest in the art world and its passing fads, untrained in conventional techniques, unconcerned about the responses of others to their creativity, and divorced from any concern with financial gain. It is most commonly defined as an innate creative passion that consumes and dominates the lives of people who have been marginalized by mainstream society.

To art critics and collectors, the appeal of Outsider Art lies in its essential purity. They would argue that this art is a reflection of innate, untainted creativity that provides a window into the innermost recesses of the human soul. Outsider Art wells up irresistibly from deep within the artist, uninfluenced by how others might view the work and with no regard to possible monetary reward. Thus, Outsider Art is free of the contaminants and criticisms leveled at the contemporary art world.

I am often asked about the roots of Judy's creativity, about how after thirty-five drab institutional years, she could address the world with such power. The answer must, in part, lie in her memories of our distant

childhood, memories that years of repression and neglect could not destroy, years when we shared a tactile world, rich in color, shape, and feel. It also speaks to the strength of the creative forces that lay dormant within her all those fallow years, creative forces that lie within each of us.

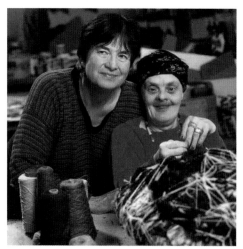

Joyce and Judith Scott at Creative Growth

In our society and formal educational system, intelligence is codified and graded in terms of standardized testing. However, creativity emerges and exists independent of cognitive ability. It is another expression of intelligence that occupies a different area of the brain and cannot be measured or even recognized by IQ testing. Artistic endeavor bypasses the limitations of spoken language by emphasizing instead visual and symbolic language, so allowing society at large—mainstream society—to glimpse a creative world less influenced by practical distractions and obsessions such as paying the mortgage, shopping for groceries, or driving to work. It is often a world more open to nature, to beauty, and to loving relationships. For these differently-abled artists, their art and their creative writing provides a practical way to contribute to society, to bring greater meaning and purpose to their own lives, and to bring joy to the entire family, who can know their loved one as creative and productive, rather than limited and negatively defined by disability.

BREAKTHROUGHS IN CREATIVE WRITING

This volume includes a collection of writing which speaks to universal themes: the need to be accepted; feelings of being different; longing for romance; searching for the meaning of life and one's place in the world. The moral questions of how to deal with pain, suffering, loss, and discrimination are also examined in these moving poems and stories.

The writers grapple with the desire to believe in themselves and to be all that they can be. They seek to be understood and accepted just as they are. Through their work, they often find a way to celebrate their differences and transcend their disabilities, and in doing so, come to recognize their own gifts.

Most of the issues confronted by these poets and writers are no different from those faced by any other adolescents and adults in this culture. However, the added developmental challenges of being an adult with Down syndrome are articulated with clarity, truth, and poignancy, and in a way that aims to include and inspire others. These challenges include the lack of choice and control many individuals may experience in their lives, and their awareness that they must make their way in a society that does not entirely recognize or appreciate their unique abilities and gifts.

This is a new generation of adults who are discovering their voices. This collection of poems, songs, and short stories is written in a way that borders on the revolutionary in terms of earlier conceptions of Down syndrome and language ability. It enters new territory of mind and spirit, and reveals a depth of feeling, insight, and self-awareness that forces us to reexamine our understanding of the abilities and potential of these writers.

We see the use of abstract and metaphoric language. Until recently, those with Down syndrome were seldom given the space and support to develop these skills. People with Down syndrome were often assumed to be incapable of such a level of complexity of thought. Given that the expansion of opportunities to explore language through poetry and story-telling has only become widespread in this recent generation, it is inspiring to imagine the creative expression that the coming years will bring.

The sophisticated use of these and other poetic techniques can be found throughout the volume in songs such as Danielle Barry's "Girl You Beautiful" and Allison D'Agostino's "Guilty as Charged." In "My Life," the writer, Jillian Berube, shows a musical and rhythmic use of language and repetition. Extended use of metaphor can also be found, as in Allison Stokes's "Night Worries":

"Every night, before I fall asleep,
these worries gnaw at me
like a panther.
They claw at my thoughts
and
bite through my soul."

In the short story *Henry and Ethan*, also by Allison Stokes, realistic dialog helps us gain insights into the suffering created in the wake of bullying.

This is not the work of children. If you placed these works in an anthology of creative writing by emerging adults, they would be indistinguishable from the general population. This volume chronicles the development of self by unique individuals journeying to find their place in the larger world, a world that has too often been full of closed doors and ignorant of the gifts they bring, but a world that is now changing, with more change and opportunity to come.

A New Horizon

Too often in the past people with Down syndrome spent their days in workshops, where they earned meager wages, performing mindless, repetitive tasks. One has to ask how much creativity has been drowned by boredom in such environments, how much society has lost by failing to recognize the talents that lie dormant

behind the mask of disability. By creating more and more places like Creative Growth around the globe, we stand to enrich society with a mother lode of untapped artistic genius, while at the same time improving the lives of countless nascent artists, who will otherwise find no means of expression for their creative gifts.

Fortunately, in the United States and other developed nations today, there are more and more opportunities for artists and writers with Down syndrome to develop their talents. Many of the teens and younger adults with Down syndrome whose works are featured in this collection have been included in mainstream art, literature, and writing classes in school or recreation programs since an early age. In addition, programs similar to Creative Growth aimed at nurturing creative talents in adults with disabilities have been established in many parts of North America. These programs have helped many of the older contributors to this book hone their abilities and find their voices.

In other parts of the world, however, people with disabilities are less fortunate, for they often lack the opportunities and the facilities needed to develop their creativity. But we live in an age of change. Some twenty years ago, my husband, Dr. John Cooke, and I started The Bali Children's Project, a nonprofit created to help disadvantaged young people in rural Bali escape poverty through education. In 2013 we are poised to bring another dream to fruition—we are creating a program for artists with disabilities in Bali, based on the principles and methods of Creative Growth. This is a manifestation of our conviction that art gives a voice to those marginalized by society at large. In Bali, art is such an integral part of life that there exists no word for it in the Balinese language. Yet sadly, disability in Bali is regarded as some form of karmic retribution, reflecting badly on the family, and so those with disabilities are often kept hidden, overlooked and largely ignored. We are working to integrate those with disabilities in Bali back into society through gaining recognition for the contribution made to the community by their artistic creativity.

CONCLUSION

The amazing works of art and creative writing in this volume carry a powerful message, helping to change attitudes in this society and others, where there is still much ignorance concerning the talents and gifts of those with Down syndrome. Here we discover that persons with Down syndrome may not be so much disabled as incredibly gifted. It is just that their gifts, like any beautiful living thing, need some space and light to grow.

A Room of Golden Shells stands in silent but powerful testimony to the creative potential of those with Down syndrome and the value of art in the landscape of disability. We are greatly honored to have been asked to write this introduction.

Joyce Wallace Scott is a published poet, writer, and clinical hypnotherapist. As an educator, RN, and developmental specialist, she has worked for many years with children with Down syndrome and other special needs. As an advocate for people with disabilities, she has appeared on television and in films, addressed conferences and clubs, and spoken at museum and gallery openings. Joyce was a speaker at the International Down Syndrome Congress in Dublin in 2009, and at the VSA international conference in Washington, DC, in 2010. In 2011 she appeared on the BBC program *The Culture Show* about the Museum of Everything's exhibition of Judith's work. Currently, she serves on the advisory board of Creative Growth in Oakland, CA, the first art center in the world for artists with disabilities.

Joyce's primary career has been as a Parent-Infant Specialist working with mothers and high-risk babies. She has also worked as an adoption and reunion counselor, and is a founding director of Birthways, a Bay Area educational and referral service for pregnant women and new mothers. She has taught in inner-city schools, delivered babies, and done hospice work with the dying. With her husband, Dr. John Cooke, Joyce is currently involved in setting up the first program for artists with disabilities in Bali—The Judith Scott Arts and Disabilities Project—and is exploring opportunities for establishing similar art centers in other cities and countries.

For more information about Creative Growth and Judith and Joyce Scott, their respective websites are wonderful places to get started: www.creativegrowth.org and judithandjoycescott.com.

Gail Shafarman, Ph.D., is a licensed psychologist who maintains a practice in Berkeley and San Francisco, CA. In addition, she is a prize-winning poet and artist who has had her poetry published in many literary journals. Dr. Shafarman's interest in art and disabilities was nurtured by her fifteen years of experience as a developmental specialist on the staff of the Parent-Infant Program, Children's Hospital, Oakland, CA.

The Gleaming
Fiona Morris

You know that some days life can't be like this.

Awaken to a room of golden shells, gleaming.

Every day.

Fiona Morris's biographical note is on page 208.

Megan Bengtson, 26, was born in Virginia but grew up in Georgia. She and her family now live in Fayetteville, Arkansas, where they quickly found Life Styles, a nonprofit for adults with developmental disabilities. Megan attends their College For Living classes, including education, drama, and art. She enjoys making collages by cutting the paper and then painting on top (as with her featured work, *A Bird*), as well as drawing dots and smoothing paint around on boards. Sometimes she paints so exuberantly that she has to take a shower afterwards.

Megan's dream is to appear on stage—preferably on Broadway, since she loves music. Her favorite shows are *Wicked* and *Glee*.

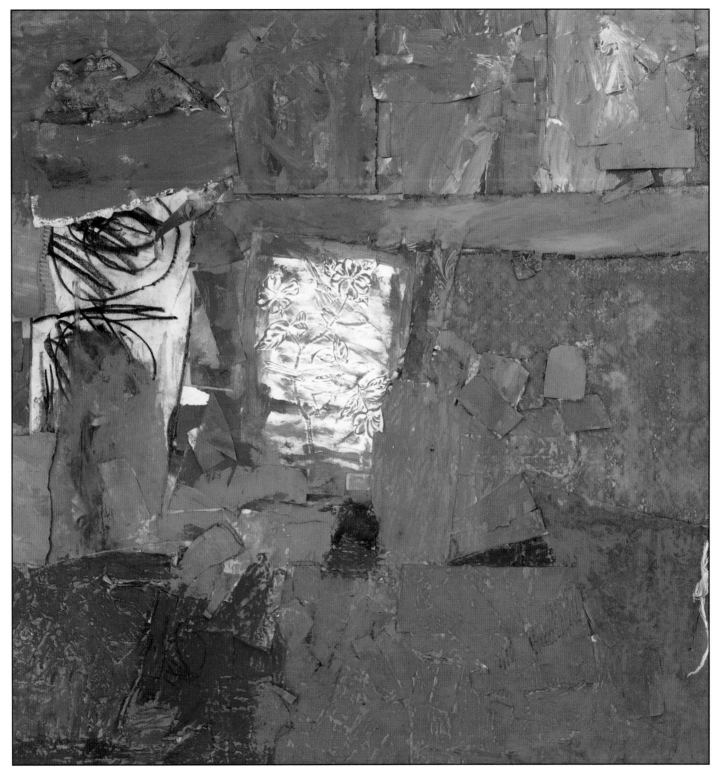

Flag over the Farm by Jackie Bouquio

Jackie Bouquio was born and raised in Staten Island, New York. She is 31 years old and has been working at the Staten Island Children's Museum for ten years. As part of her job, she is in charge of "Paint Day." She sometimes demonstrates different painting techniques (she likes to paint abstracts) and tries to inspire the children who visit the museum.

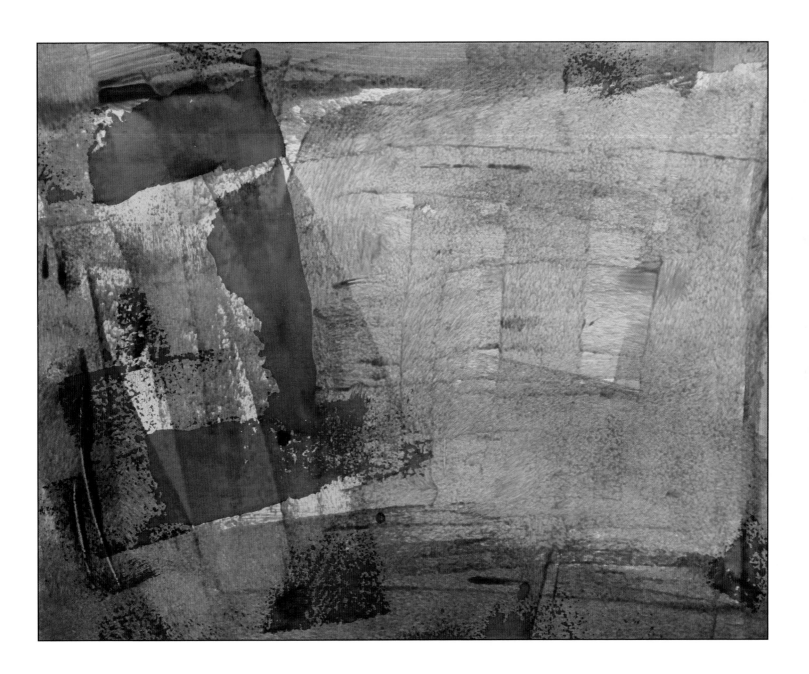

Marissa Erickson is 20 years old and lives in Alameda, California. Art is her life. She loves to paint, draw, and work with clay. She attends two art studios and has great teachers. She likes to show her work and sell it.

Marissa also enjoys drama, dance, hanging out with her friends, and swimming. She loves music too and tries to attend as many concerts as she can.

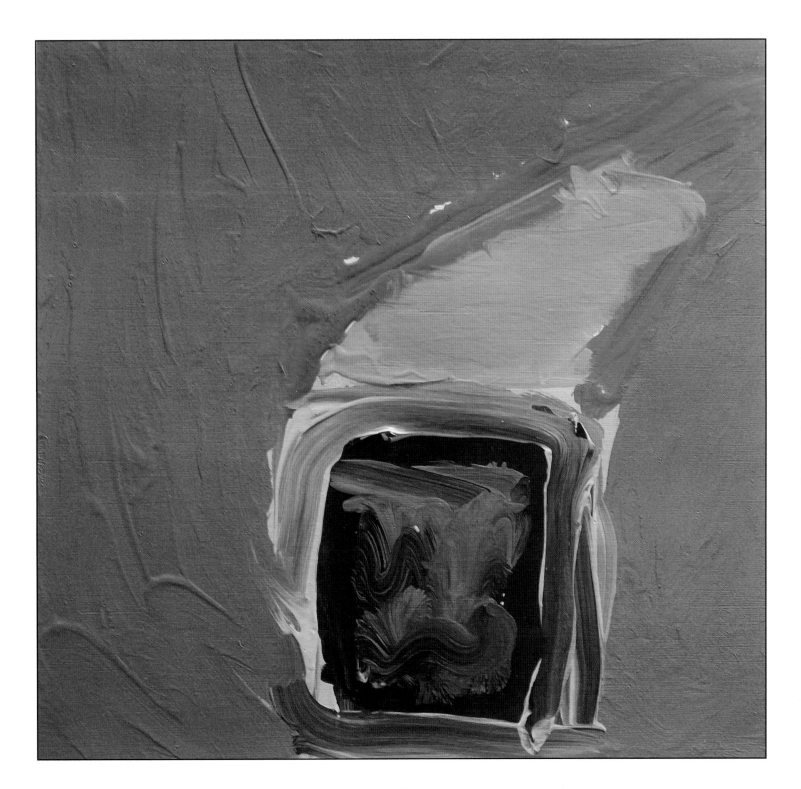

Beth Ann Gregus, 33, lives in Granite City, Illinois. She has completed a special program at Lewis & Clark Community College (previously known as Lewis & Clark Junior College), and is currently attending a program there called College for Life.

In the past, Beth worked in Central Supply at the local hospital, but was laid off when the hospital changed owners. Since then, she has continued to pursue her interest in the medical field by volunteering at the hospital. Beth's heart picture was inspired by her love for the medical jobs that she would like to do.

When she is not painting or doing ceramics, Beth enjoys church activities, as well as bowling, dancing, swimming, and spending time with her family and friends.

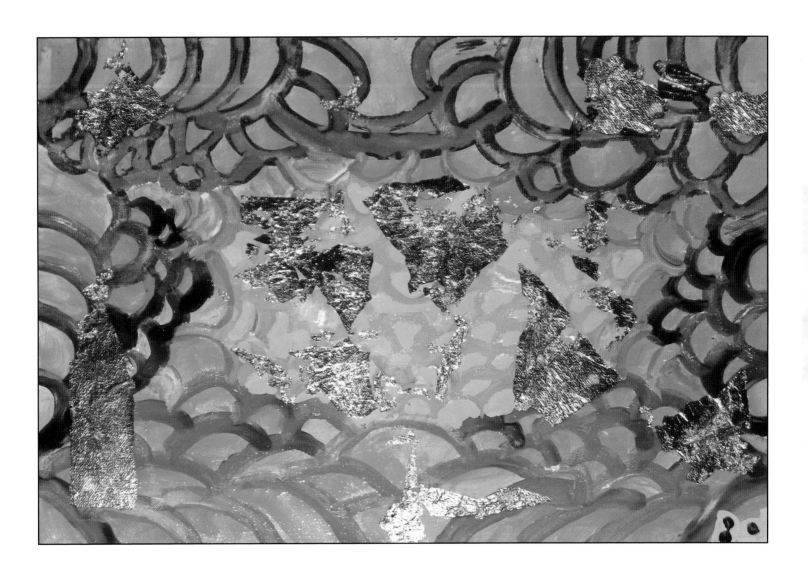

Virginia Horan, 51, lives in Guilford, Connecticut. She credits her family with getting her involved in art and motivating her to continue. Her parents always encouraged her to take art classes and to paint. Her sister Judy, an artist living in Mexico, has introduced her to different mediums and completed many art projects together with her over the years.

Ginny believes that her art has always given her a place to feel free and express things she doesn't know how to express in other ways. She loves color, especially greens, blues, reds, and yellows, and likes using large brushes to make bold lines. Her artwork reflects the variety of life that is important to her.

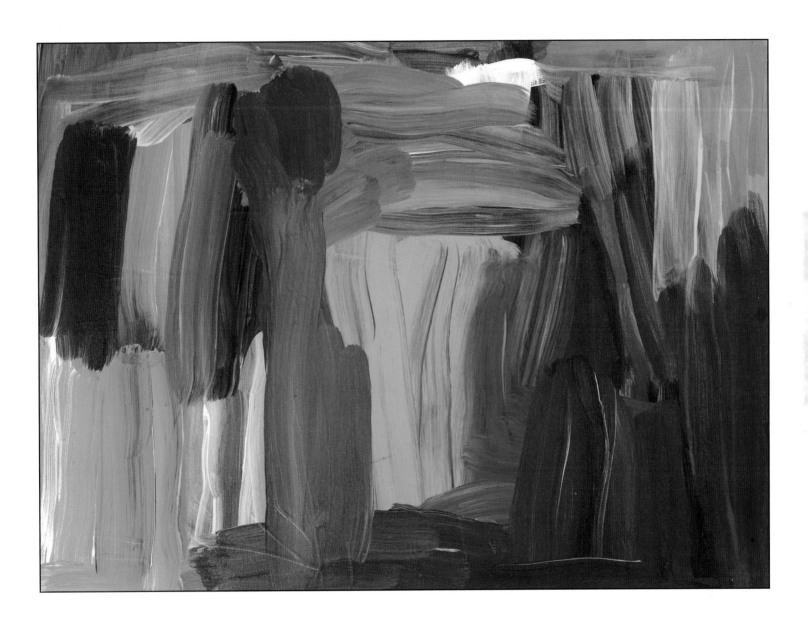

Abigail Macedo, age 18, is a Florida resident who has a dual diagnosis of Down syndrome and autism. As a baby, she had open heart surgery, followed by a pacemaker implant and an infection. At the age of seven, an ulceration lead to the removal of the pacemaker. Abby cannot talk, read, write, or communicate her needs and thoughts in the expected manners, but her family and friends understand her emotions and what she has to share. Her mother notes that if you look Abby in the eye, you can see a spark, a light. It is this spark that ignited her mother to keep helping Abby to develop her art.

Abby started her artwork at the age of three. Initially, she used a finger painting technique. Slowly, the use of a brush, first with watercolors, then with acrylics, took hold. Over the years, art has given Abby a way to communicate her emotions. *Dancing Grasses* (page 15) is such an example: Abby's sweeping strokes fall onto the canvas in broad strokes. These are her emotions in colors and motion.

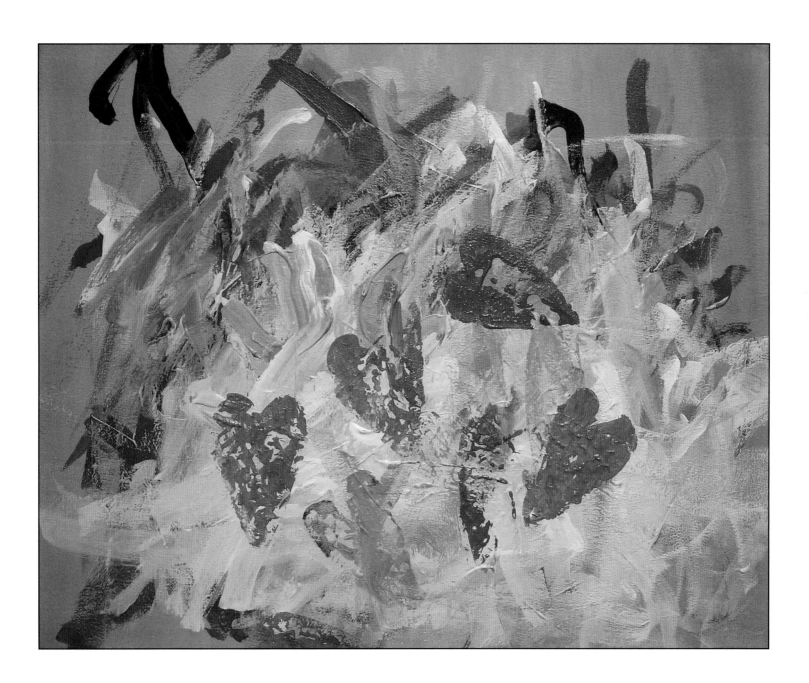

Abigail Macedo's biographical note is on page 12.

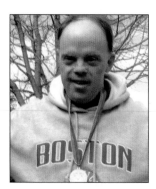

Scott Regan, 51, is a Connecticut resident. He takes
art classes through SARAH, Inc., a chapter of the Arc
located in Guilford, CT. Scott created the painting
reproduced here as a Christmas gift for Cindy, the
Recreation Director at SARAH. He has also created
artworks for his girlfriend's church. In addition to his
interest in painting, Scott is active in Special Olympics.

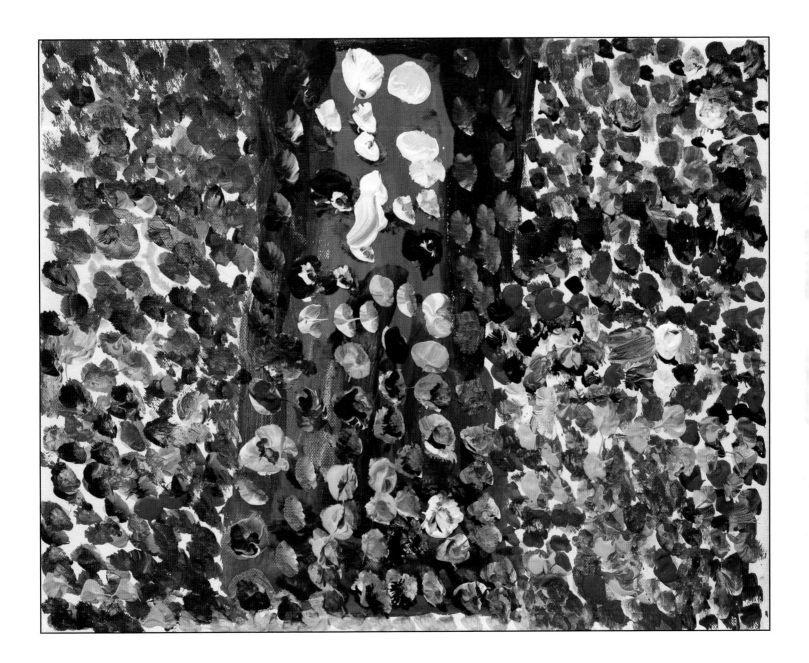

Kathryn Richardson, age 31, is a Californian who has been painting since she was 5 years old. Lately, she has specialized in creating geometric and free-form designs, using bright colors. Kathryn also enjoys writing poetry; her favorite topics are love and the beautiful world. One day she hopes to be able to sell her artwork and poetry.

Jessica Rockoff is 29 years old and lives in West Windsor, New Jersey, with her mom and dad and her cat, Tommy. She works at Wegman's supermarket, where she conditions and restocks the shelves.

Besides painting, Jessica loves listening to music and watching romantic comedies. For sports, she competes in bowling and cross-country skiing. She recently took a photography course and also enjoys acting. In addition, Jessica enjoys a wide range of foods from different cuisines, including sushi, Chinese food, and American foods. She has traveled to Israel, China, Japan, California, Florida, the Czech Republic, France, Italy, England, Hawaii, and Canada, where she recently attended a wedding. She loves weddings.

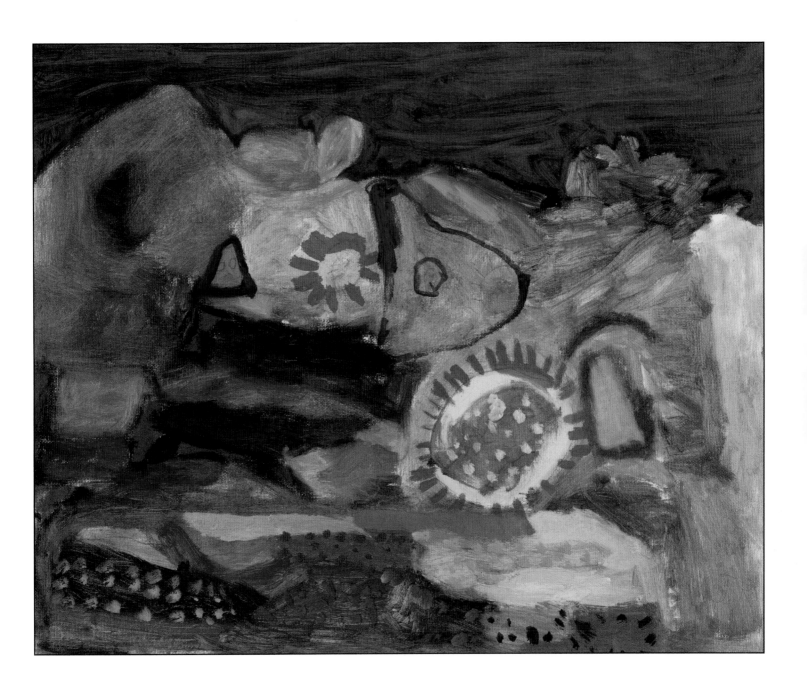

Michael Schimmel is a 31-year-old New Yorker who has participated in art programs his whole life. When he was 25, he had his first exhibit and birthday party at Galleria in Manhattan. The exhibit showed his favorite works created in classes at the Metropolitan Museum Discoveries program, the 92nd Street Y, and school. On his thirtieth birthday, he had an exhibit and party at Nina's Argentine Restaurant and Gallery in New York.

Michael's untitled work reproduced here was done under the guidance of his art teacher, Katie Fitzsimmons, and his support worker, Jay Catlett.

Art is in Michael's blood. His father is a composer and musician and his mother is a dancer and choreographer. He is interested in color as texture and texture as color.

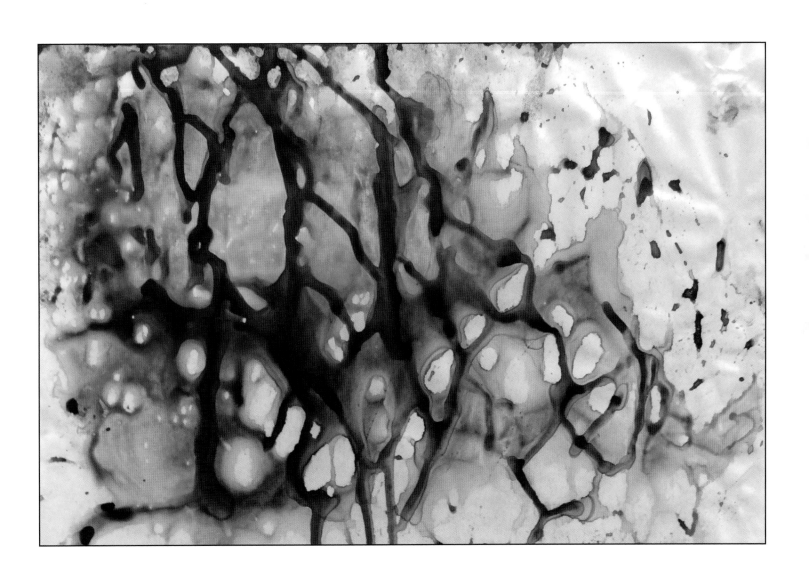

Andrea Sharp, 45, has been married for 17 years and lives in a beautiful home in Arkansas with her husband, Paul Sharp. She has been employed at Toys 'R' Us for six years. Andrea has been involved in Life Styles, a nonprofit for adults with developmental disabilities, for twenty-four years, and, for all those years, has been a spokesperson for Life Styles. She has given speeches and has been interviewed for newspaper articles, and always throws the polo ball in to start the match for Life Styles's biggest fundraiser.

Andrea has been taking art classes at Life Styles for seven years. When she paints, she prefers to draw the picture first. She mixes her own colors and takes her time. She also likes to sew and do embroidery, but expends most of her creative efforts on painting and drawing.

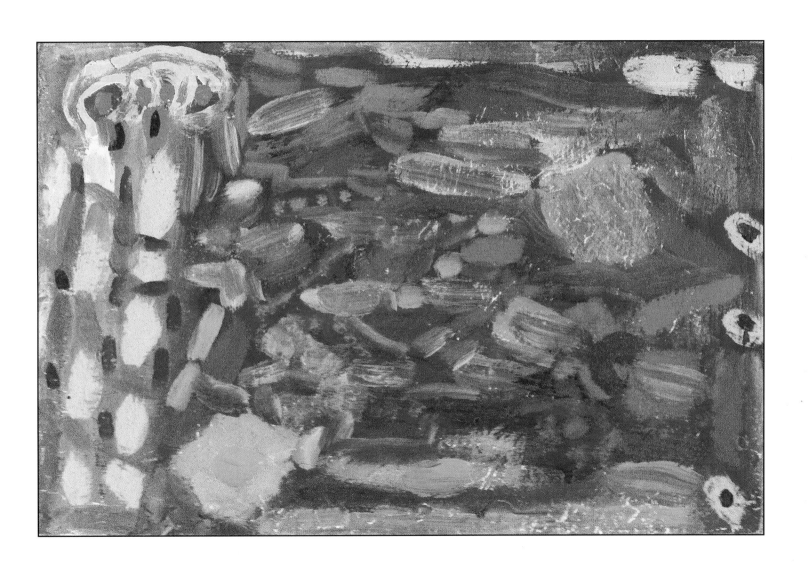

Zachary Simon is 19 years old and attends Montgomery High School. He lives in Santa Rosa, California, with his parents, younger brother, three dogs, and a cat.

When he was younger, Zachary could walk and run, but due to a problem with his spine, he can no longer stand or run. He can, however, walk ten steps with a walker, wheelchair dance, and shoot basketball hoops. Not surprisingly, Zachary likes physical therapy.

In his spare time, Zachary enjoys drawing, coloring, and painting, and he has a huge collection of pens, pencils, colored pencils, and markers. Zachary's other interests include singing, video games, grocery shopping, and going to services and activities at congregation Ner Shalom.

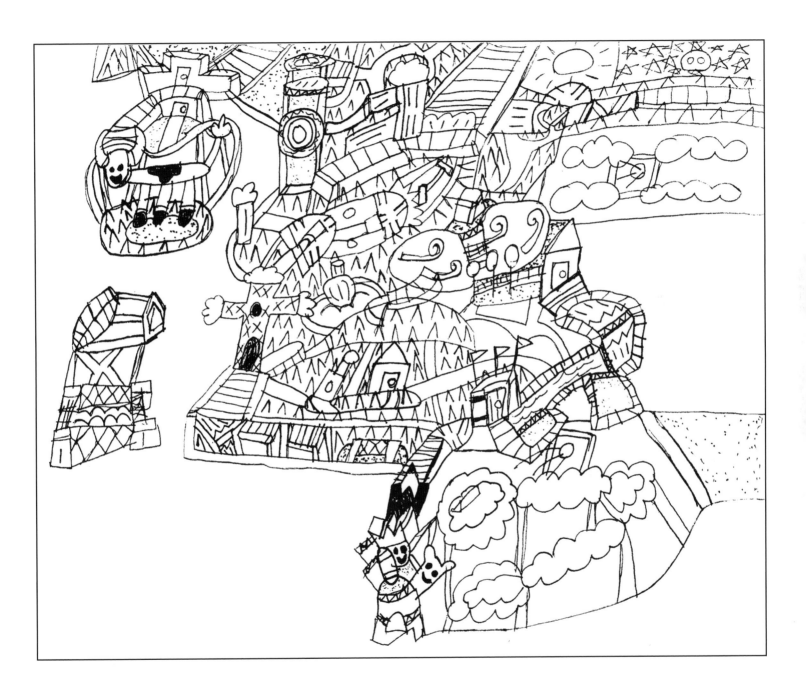

Margie Smeller, 27, is a lifelong resident of Frederick County, Maryland. She started her art career at an early age in the usual fashion with crayons, sidewalk chalk, and finger paints. She has always had a keen eye for color, and that is reflected in many of her pieces of art. Most of Margie's work is done with mixed media on canvas.

As a student at Linganore High School, Margie's drive to do art attracted the attention of the art staff, who encouraged her to continue her art after high school. They entered her portfolio in a juried selection for the Art Honor Society, and Margie was admitted as a member. She currently shows art at the Artist's Gallery of Frederick and at Art Enables in the District of Columbia. Her works have been displayed in galleries from New York state to Portland, Oregon.

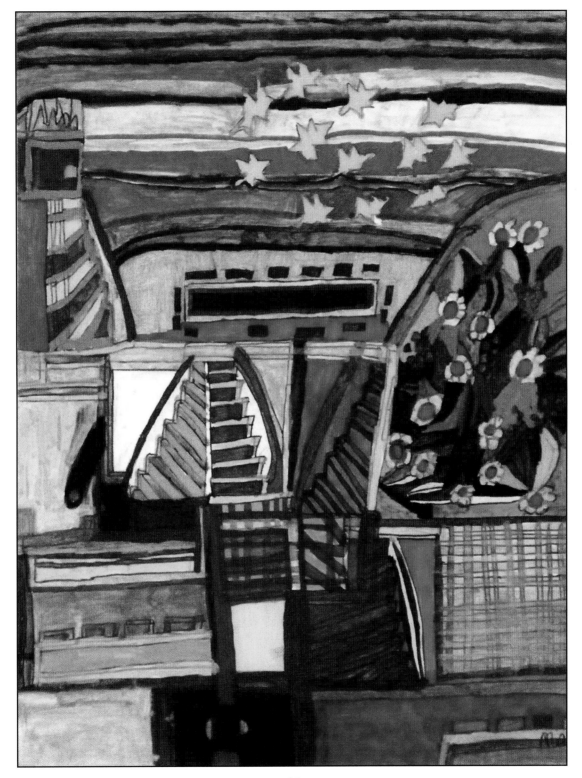

Let it Snow by Margie Smeller

Margie Smeller's biographical note is on page 28.

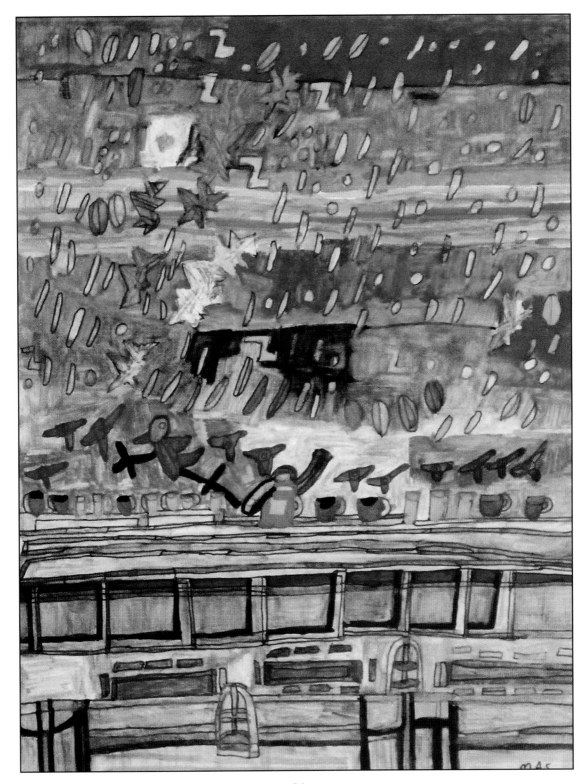

Margie Smeller's biographical note is on page 28.

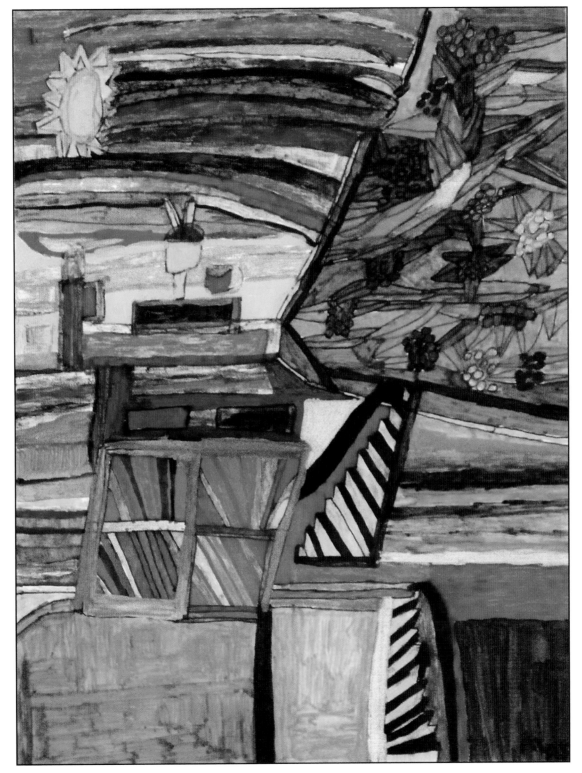

Amy E. Sochia, 22, has enjoyed art since she was introduced to finger painting in preschool at the age of 2. As a student at Carthage High School in New York, she took art classes in drawing and ceramics. She likes painting on canvas best, as well as creating bowls out of clay, and she especially likes using reds and blues.

Amy never keeps a piece of artwork for herself, because what she loves even more than creating is sharing what she has created. Her favorite painting, *Cat in the Hat and Gertrude McFuzz from Seussical the Musical,* was created for her sister, Stephanie. Amy likes to give her artwork to other people because, she says, "It's beautiful and I love them."

When she is not creating art, Amy loves to sing, dance, and act. She has been in several theatrical productions, including *Seussical, Once Upon a Mattress, The King & I,* and *Beauty and the Beast.* Amy dreams of going to Broadway someday. Amy attends a day program where she volunteers at local nursing homes and delivers for Meals on Wheels.

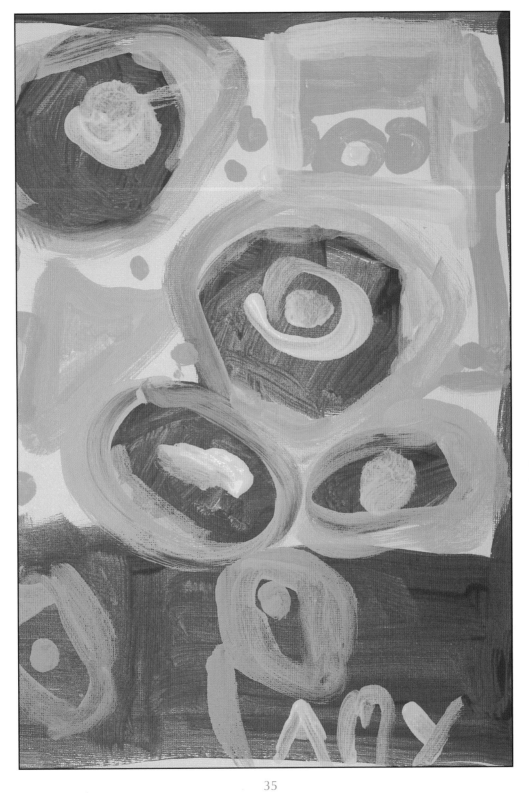

Ashley Voss is a 28-year-old artist who primarily works in acrylics on canvas. She prefers the process of loading multiple colors onto her brush at once. Applying them to the canvas with a single brush stroke, she is able to achieve depth and create texture.

Ashley was born with a congenital heart defect and, at age two and a half, acquired additional disabilities as the result of complications from her first open heart surgery. Ashley is cortically visually impaired and legally blind. She also lost her ability to speak and mostly uses sign language and a speech generating device to express herself. Her art is another way for her to convey her feelings and her interpretation of the world around her.

After years of very limited art instruction, Ashley was unwilling to let art pass her by and took up painting at age 24 with a private art instructor. Born in New Orleans, Louisiana, Ashley has lived most of her life in Tulsa, Oklahoma, with her parents, Harold and Kimberly, and sisters, Megan and Wendy. Aside from her job providing mail services through her own company, she is a movie fan and enjoys dancing to pop music.

Dusk Over Peaceful Seas by Ashley Voss

Ashley Voss's biographical note is on page 36.

Hidden by Ashley Voss

Ashley Voss's biographical note is on page 36.

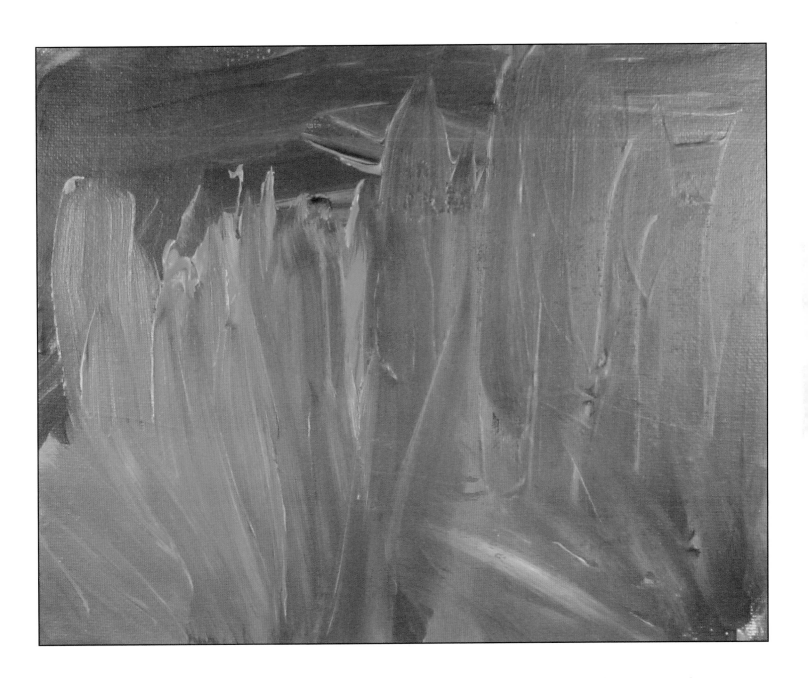

Laura Whitfill, 17, lives with her parents and two of her eight siblings in Hardinsburg, Kentucky. She is homeschooled and is a senior this year.

Laura loves to draw designs and color them with markers, often while watching TV, which is another of her favorite activities. Last year, she entered one of her drawings in the Growing Awareness Art Contest sponsored by Down Syndrome Footprint and was a winner. Laura was very happy about the recognition, as one of her goals is to become an artist.

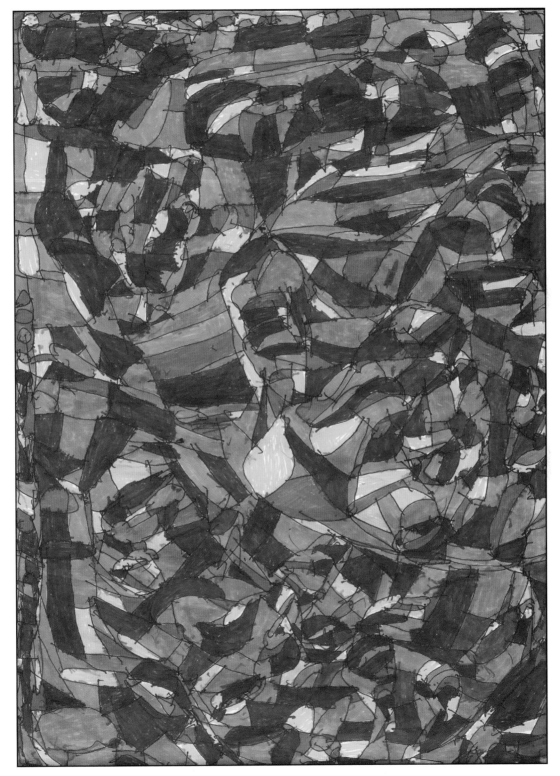

43

I Love Dance by Patrick Zolnowski

Patrick Zolnowski, age 15, has an affinity for the creative arts. He loves
to draw, paint, listen to music, and dance. While attending a Board Of
Cooperative Education Services (BOCES) program at Heim Middle School in
Williamsville, New York, Patrick participated in art classes. After painting a
Valentine heart at school in blue, green, and yellow, he was asked to create
another one to be auctioned off at a fundraiser for his dance program,
danceability, Inc. The resulting painting, reproduced here, brought in a lot of
money to help the dance program.

Patrick's other interests include playing soccer with the TOP Soccer
program and attending the local adapted recreation program. He also
participates in bowling and track through the Special Olympics in his area.

Patrick is currently attending a BOCES program at Clarence Middle
School in Clarence, New York. He lives with his parents and younger sister
in Depew, New York.

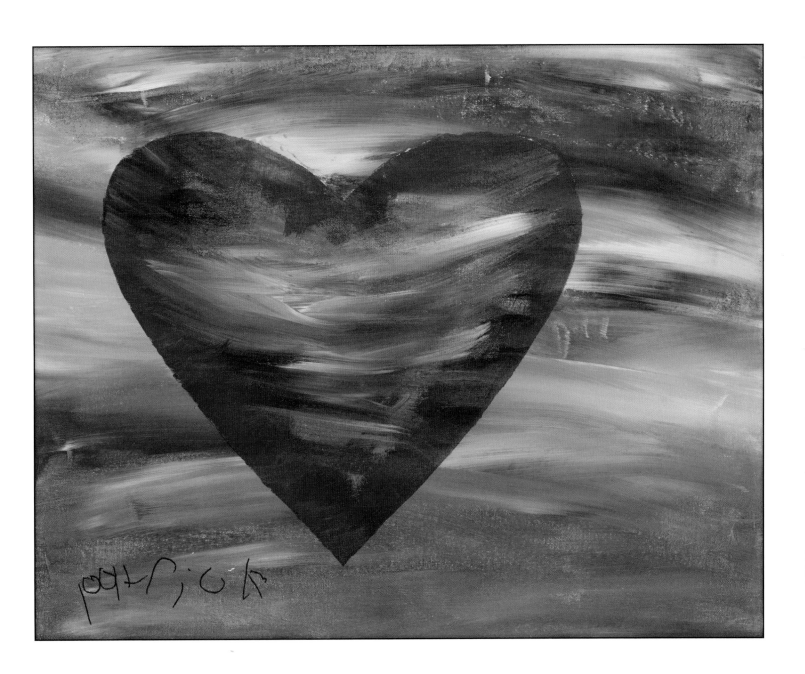

Jillian Berube, age 22, is presently pursuing her interest in fashion by working at TJMAXX as an associate. She also volunteers to work with children at the Extended Day Program at J.R. Biggs Elementary School and with young children at a Head Start program. She has been active in sports all her life, swimming, playing baseball and soccer, and competing in Special Olympics. In addition, she takes classes at Mount Wachusett Community College and has appeared in plays at her high school and at the Theater at the Mount.

Jillian is involved in a self-advocacy group and the North Central Citizen's Advisory Board for the Department of Developmental Services. She has also served as a self-advocate on a steering committee for Massachusetts Families Organize for Change and is a member of the Massachusetts Down Syndrome Congress (MDSC) Self Advocate Advisory Council.

In her free time, Jillian writes songs, goes to dances, kayaks, and enjoys sleepovers and Skyping with friends. She notes that her song "My Life" talks about the person she really is and the things she wants to do in her life. She believes she will accomplish her goals since she is a very hard worker and tries to succeed in everything she does.

My Life
(Song)

Jillian Berube

My life can be special, it can be anything I want it to be

I want to express who I am inside

Everything is changing in front of me

When I was younger in my life, I would have never known I would be where I am

My life is a lot different than I thought it would be, I am changing

When I was younger I made memories that I keep with me

I am not as different as people thought I would be, yeah

This is me

Letting my past go is hard, I always carry it with me

I sometimes feel like I am the only one with a disability

I am the kind of person that I was meant to be

My voice can be heard from my story

I am who I am meant to be!

Aliza Claire Bible, 25, has completed a two-year postsecondary program at Leslie University, and also attended the Cutting-Edge program at Edgewood College in Wisconsin. She works with People First Wisconsin as a Legislative Liaison between People First and the Wisconsin Board for People with Developmental Disabilities.

Claire's poetic life began at the age of sixteen. She writes her poems longhand in journals and notebooks that she keeps close at hand, and when inspiration hits her, she flips them open and writes. For Claire, poetry is therapeutic and it has grown up with her. The poetry that she wrote at sixteen isn't what she writes now, but it's always a part of her. She has written volumes of poetry, but each poem is special to her in some way. She doesn't number or date them the way Yates was known to do—rather, she just lets them flow into each other. So far Claire has put together three books of her poetry and hopes to soon begin to construct her fourth book of poetry from her early years.

Claire believes that the two poems that appear here fit together like puzzle pieces—together they are strong, but they are also strong on their own.

Man in the Moon

Aliza Claire Bible

The man in the moon plays a lazy saxophone
A haunting sweet magical moon dance
The wind brushes against my cheek a caress
It carries the haunting notes
Of the man in the moon's song
To play in my ear
So I can listen in to that smooth cool jazzy saxophone
The man in the moon knows my heart
The wishes that hang on the North Star
He keeps my secrets
Every once in a while he smiles mischievously
As if he knows something that I don't
Smiling down at me a Cheshire cat smile
That catches my eye makes me chuckle
And I wonder what he knows

The man in the moon fishes off that half of moon
He casts out to only reel in and cast out again
It is the simple movement of casting that it seems
He loves the most
His lake the clear cool darkness
Dusted with and by star shine

The stars shine in your eyes
The Milky Way stretching bending out
Much like a ribbon of highway

I am entranced fascinated
As I lay on the dewy thick grass that is spongy under foot
In the curl of a strong arm
The man in the moon holds me tonight

The man in the moon plays a lazy sax
I close my eyes simply listen
To those who stare in wonderment
I offer a Cheshire cat
Half a sliver of moon smile
Mischief tugging up the edges
I wonder what the moon man would be like on a date
Man in the moon, moon man
By any other name you will always be
A mystery to me

World Melts Away
Aliza Claire Bible

The world melts away under my tongue
I am swinging off that half of moon
My feet bare skim over the stars
My toes brushing Venus's many rings
Then I swing out again
I lazily pump the swing in long languorous strides
Stretching my legs far out ahead of me
Leaning far back threatening my sense of balance
Doing this would usually scare me now it thrills me

Makes my toes curl as I briefly grip hold on to Venus's many rings

And as it spins I slightly spin

Letting go swinging out in a pretzel twist fashion

That has me laughing because it's just so much fun

That I swing out just to do it again

The world melts away under your touch

Like superman you take me up to the stars

Sit me on your lap on the swing that hangs off that half moon

We swing together a lazy butterfly with my legs

Wrapped about your waist

Your arms wrapped about mine you dip me back

My hair fanning out over the stars

Just to hear me scream with laughter

The man in the moon plays a lazy saxophone

From the corners of his mouth he smiles down on us

I have an optimistic eye on the sky

I long to swing butterfly style with you

Off that half of moon

You slip an arm around my shoulder

Your fingers brushing against my arm

I see the Milky Way in your eyes

You tighten that arm pull me slightly into you

The world melts away under your touch

I wonder to myself

That if we kissed our tongues dancing

Would the world melt away?

The world melts away under my tongue

Alex Lorton lives in Greenville, Illinois, and is 22 years old. Besides writing song lyrics, he plays the guitar. He began lessons at the age of 15 with Big Jeff at the local music store. He credits his older brother, Aaron, with inspiring him to play the guitar and write songs, and thanks his grandmother Phyllis for secretly entering some of his song lyrics in the contest for him. He also thanks his friend Don for putting his lyrics to music. Alex hopes to start his own band some day.

Alex competes in many Special Olympics sports, including bowling, basketball, golf, bocce ball, and track. Alex is a graduate of Greenville High School.

Here I Am

(Song)

Alex Lorton

Here I am with all my heart

You brought me closer

Come take my hand

I want the world to see

what you mean to me, what you mean to me.

And every time I think about you

I think about love

You appear just like a dream to me

Every time I dream about you

I dream about love

In that dream I want to say

I love you.

Lori Turbenson, 32, lives in Coon Rapids, Minnesota, in her own apartment. She has been writing since middle school, and has created enough short pieces to make a book-length collection that she has titled *Poems, Letters and Thoughts from My Heart*. Writing is important to her because it allows her to express her many beliefs—including her biggest beliefs, that she deserves respect and can achieve her dreams.

Lori has two part-time jobs. At Achieve Services, she collects and sorts the mail, and at Medtronics, she collates documents for mailing and prepares allergy kits. Outside of work, her family is a big part of her life. She enjoys being an aunt to her niece, Ellen, and her nephew, Paul. She also likes spending time with her friends and long-time boyfriend, Michael.

In her free time, Lori is a speaker for parent and grandparent groups and likes telling them about her independent life and living in a place of her own. She is especially interested in cooking healthy foods, makes all of her own meals, and helps lead a class on cooking healthy foods. Lori also sings in the Merry Music Makers choir, bowls, dances, and collects DVDs. Lori wants to see what the future will hold for her because she knows she can be a star, face the challenges in her life, and make her own decisions.

Being Myself

Lori Turbenson

I dream every night

And I think what's it like

To be a grown-up with a disability,

And learn how to take care of myself,

Learn how to sing,

Learn to dress properly,

To love a person against my will.

This is my world

Where I stand

Having faith,

Best dreams,

And wishes to command.

Autumn Horse by Katia Bigos

Katia Bigos, 31, lives in New York with her mother. Six times a month, she attends an after-hours art class, where she develops her art ideas. She excels in a variety of media ranging from painting to mosaics to photography.

Katia enjoys reading books, especially biographies and nonfiction works about music and art. She also has a keen interest in fashion, makeup, shopping, and going out to dinner. In addition, she enjoys singing and musical theater, and it doesn't take much encouragement for her to burst out in songs from the musical *Annie*.

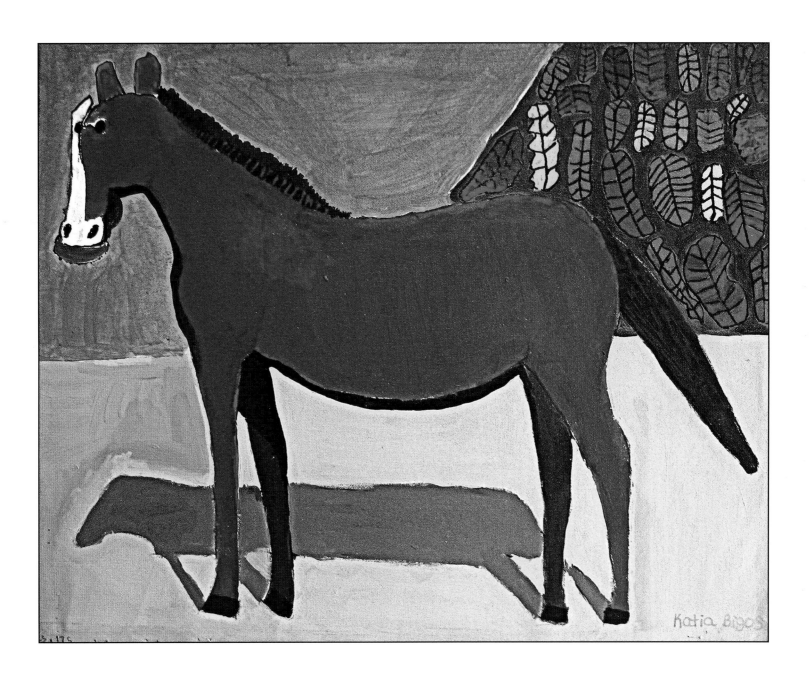

Tina Condic is 27 years old and lives in Calgary, Alberta with her family. She has been painting for nine years and enjoys it a great deal. Tina joined an art program called Indefinite Arts when she was 18 years old, and it was there that she discovered her love of acrylic painting. Tina enjoys painting all things, especially flowers, people, abstracts, and sunsets. She paints on her own at home and has recently gone back to the art program where she started. Tina is working on her dream to have an art show so that everyone can see and buy her work.

Among Tina's other interests are music, singing, movies, and writing. Her favorite band is the Backstreet Boys, and she loves going to their concerts. To see more of Tina's artwork, visit www.facebook.com/tinacondic.

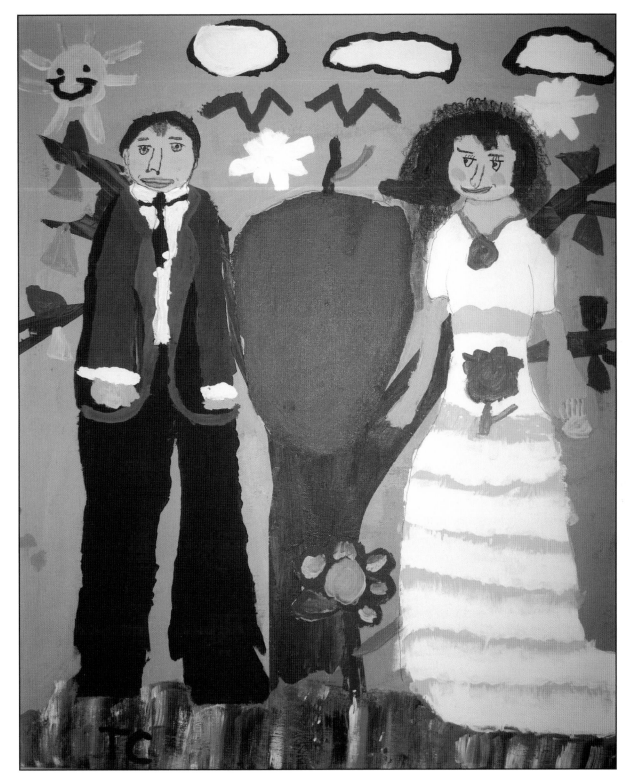

Austin Davenport graduated in 1998 from Lake Highlands High School in Richardson Independent School District in Dallas, Texas, where he was active in theater, choir, and visual arts. He attended Richland College in Dallas, where he continued his study of theater. He has performed in over twenty plays in area theaters. He has spoken encouragement as a self-advocate to many groups around the country and has served on the Boards of the National Down Syndrome Congress (NDSC) and the Down Syndrome Guild of Dallas, and currently serves on the Self Advocate Council of the NDSC.

Austin works full time at the law offices of Baker Botts in Dallas. He travels to and from work each day by foot, bus, and train.

In 2009, Austin married Christi Hockel of Walnut Creek, CA. Christi also serves on the Self Advocate Council of the NDSC. Austin and Christi often present their story together to inspire groups. They live on their own in a duplex very near where they attend church and near where they bank, buy groceries, dine out, and enjoy special coffees. They also enjoy frequent trips back and forth to California for visits with Christi's family.

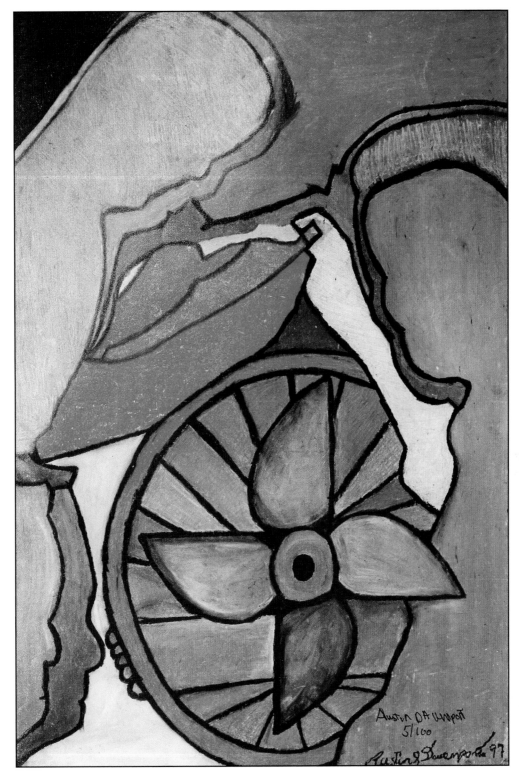

Party Taxi by Emily Dodson

Emily Dodson, age 32, was born in Colorado but now makes Texas her home. She learned to paint with her mother, who is also an artist. Emily attends art classes at The Arc of the Arts Studio & Gallery in Austin. This program is offered by The Arc of the Capital Area, which provides services for people with intellectual and developmental disabilities. At the Arc of the Arts, Emily explores her own art process, and learns new art techniques and marketing skills. Her work is then displayed and sold in the community, at The Building Bridges Art Auction & Gala and in the storefront gallery. She is also frequently commissioned to make paintings.

Emily's paintings are always recognizable from across the room due to her bold use of line and color. Emily's great imagination has led to paintings with parachuting pigs, pool parties, and aliens as the subject matter. She often incorporates a number of sketches into the same painting to create a story. Emily continues to develop her style by mixing more of her own colors, adding varieties of hues into backgrounds, and experimenting with depth and perspective. A virtual gallery of Emily's artwork is available at: www.arcofthearts.com/emily-d/.

Riding in Emily's *Party Taxi* are Meryl Streep (in the blue polka dot dress) next to Miley Cyrus, and behind them, Johnny Depp as Jack Sparrow and none other than Senator John McCain.

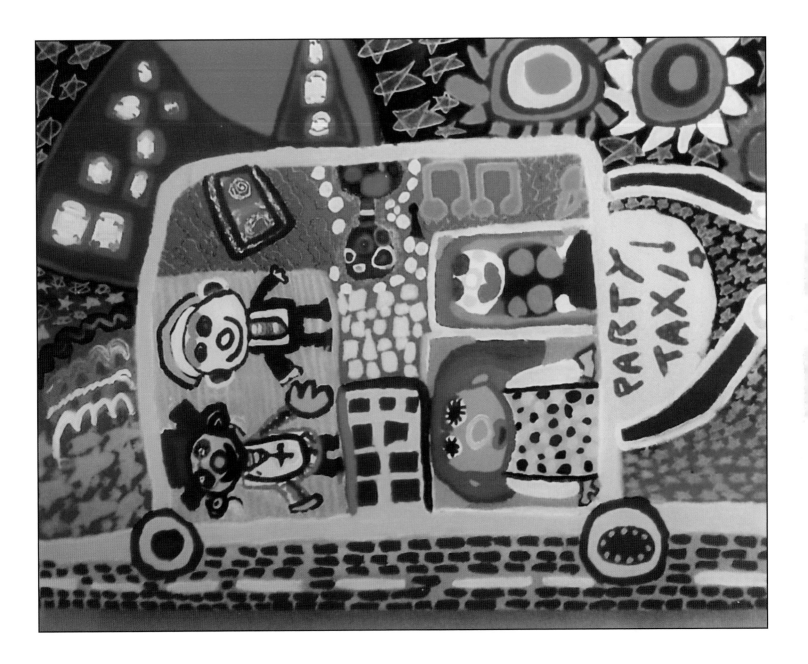

Rockin' Party Fair by Emily Dodson

Emily's *Rockin' Party Fair* was the first painting sold at the gallery opening of the Arc of the Arts. Seated around the table are Elvis, Johnny Depp, Emily's dog Sammy and cat Jasmine, a monkey dressed like a pirate, and "Wendy" from the Wendy's restaurant cup. On the table are Emily's favorite foods, including Skittles, Pixie Stix, popcorn, and a martini. The background includes the red carpet from the Academy Awards and the Statue of Liberty.

Emily Dodson's full biographical note is on page 62.

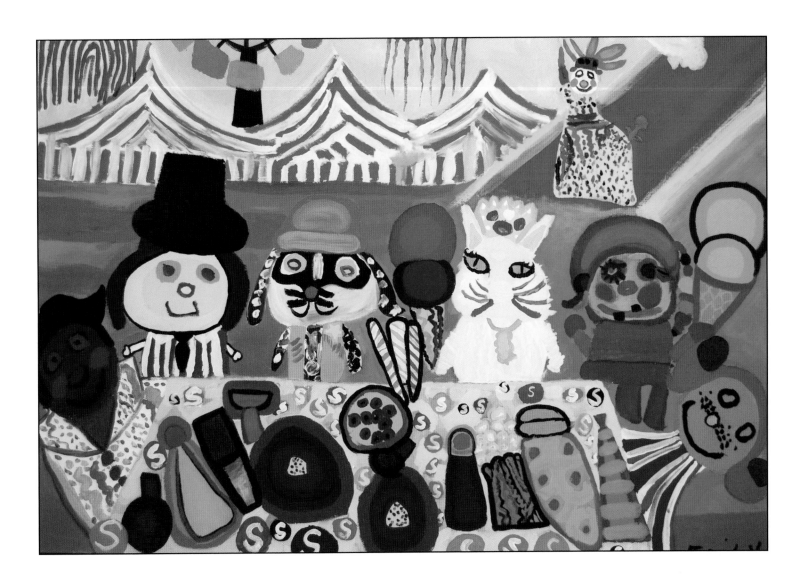

65

Samantha Downing is 42 years old. She lives independently in an apartment in Stamford, Connecticut, and receives support from ARI, an agency that provides services for people with developmental disabilities. She works twenty hours per week at General Electric, where she has been employed for the past twenty years since graduating from Westhill High School in Stamford.

Samantha has been a part of the ARI Artists' Initiative art class for nine years and has had her artwork shown in several shows in Fairfield County and in the annual ARI Art Calendar. She has also been active with Connecticut Special Olympics in tennis, skiing, and golfing. Her favorite pastimes are drawing, listening to music, and watching DVDs.

School Time by Samantha Downing

Samantha Downing's biographical note is on page 66.

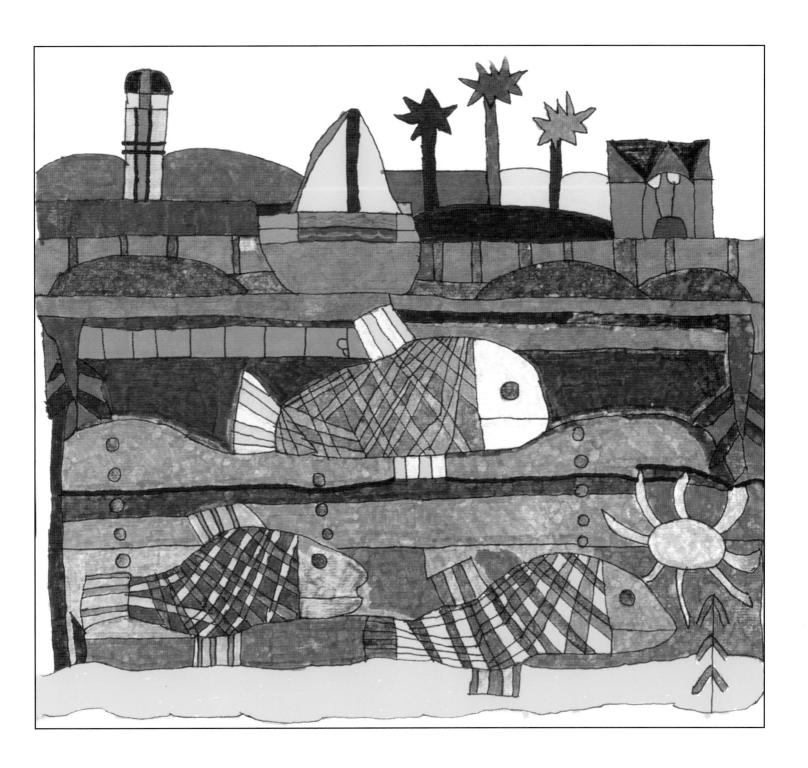

Portrait by Samantha Downing

Samantha Downing's biographical note is on page 66.

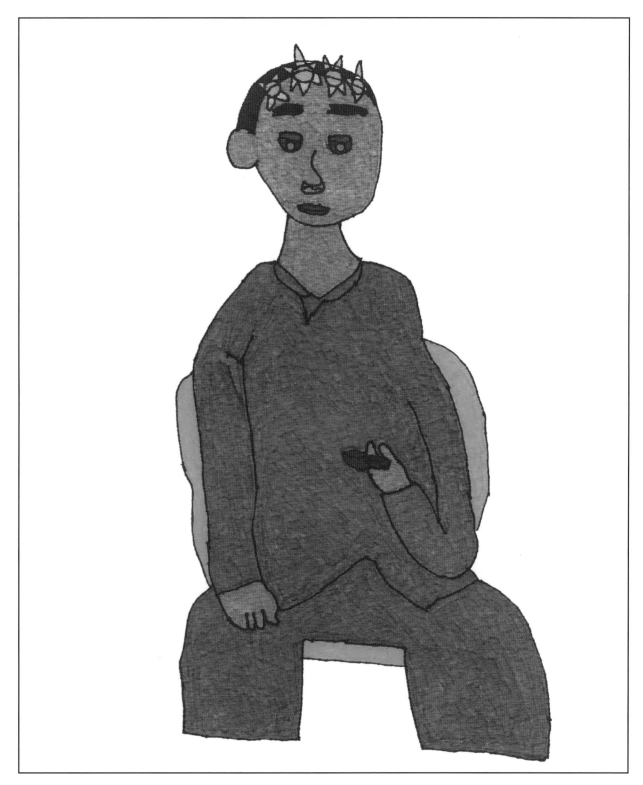

Kellie B. Greenwald, 34, lives in Ross, California, just outside of San Francisco. She is the author and illustrator of *Kellie's Book: The Art of the Possible*, a book about her life with Down syndrome.

Kellie studies art and makes jewelry at a day program in Ross known as the Victory Center. It is part of the Cedars of Marin, which operates the facility where she lives. She also works two days a week at a gallery called The Artist Within, where she sells both her art and her book.

Kellie enjoys public speaking, and has given presentations about her life at several universities, including University of California Berkeley, Syracuse University, and the University of Memphis. In addition to creating art, Kellie likes going to San Francisco Giants baseball games, traveling with her family, and listening to music—especially Hannah Montana. Someday Kellie would like to work with little kids and help teach them how to write a book like she did.

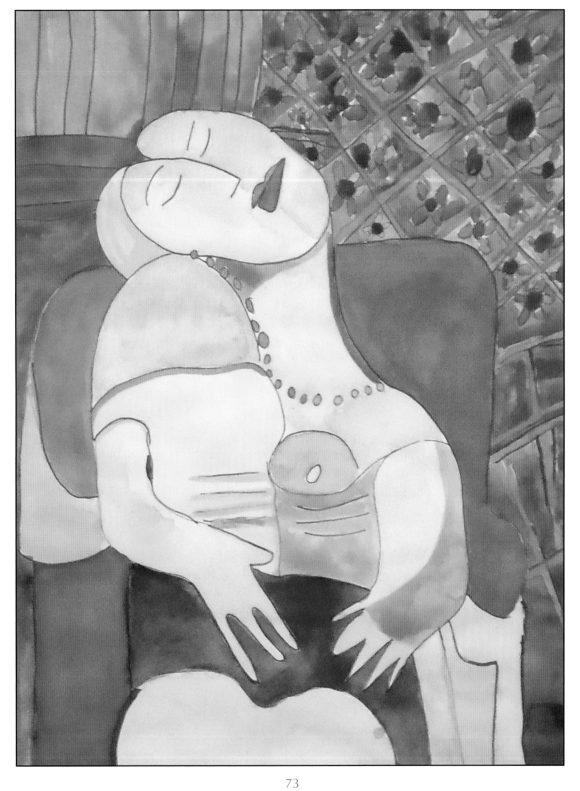

Singing in the Rain by Kellie B. Greenwald

Kellie B. Greenwald's biographical note is on page 72.

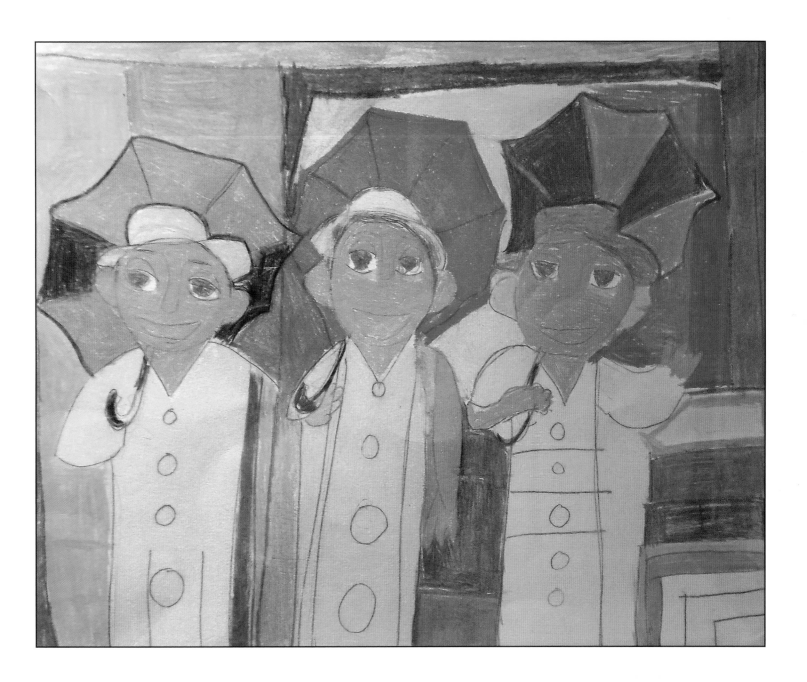

Michael Johnson is a recognized naïve folk artist. He is entirely self-taught and supports himself with his art. Collectors have come to appreciate his talent and feel compelled to buy, even during the harsh economic climate, because they see something special in his artwork. Michael's paintings express happiness, peace, friendship, his love for nature, and his compassion for animals.

Michael has been painting full time for almost 20 years. He listens to WFMT and likes to paint all day long. He sells from his website (www.artistmichaeljohnson.com) and at art exhibitions.

Since 2000, Michael has painted more than 600 commissioned portraits of pets, houses, children, and racehorses with watercolors, acrylics, and oil paints. Portraits, custom work, and illustration jobs have challenged him to develop new skills and to try new subjects. His art has been published in newspapers and magazines, has won awards and national contests, and has appeared in juried shows. Two of his paintings are in the collection of The American Folk Art Museum in New York. His peers are professional artists and illustrators. Michael is proud to be an ambassador for Down syndrome to the general public.

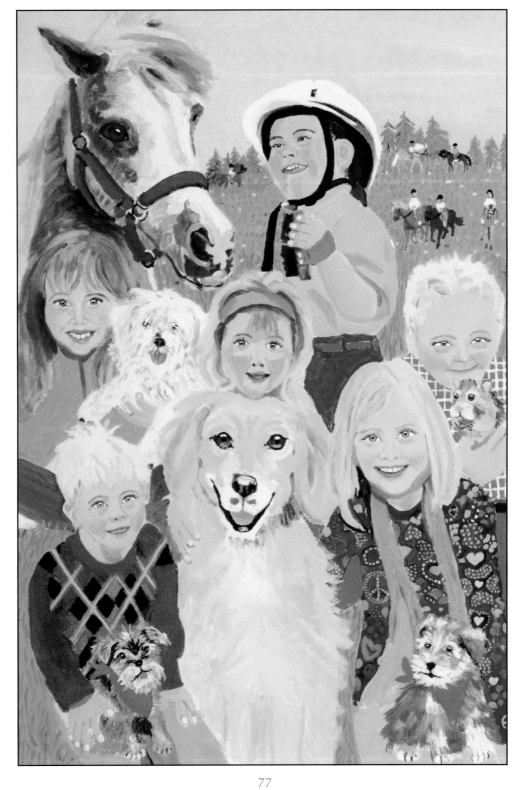

Michael Johnson's biographical note is on page 76.

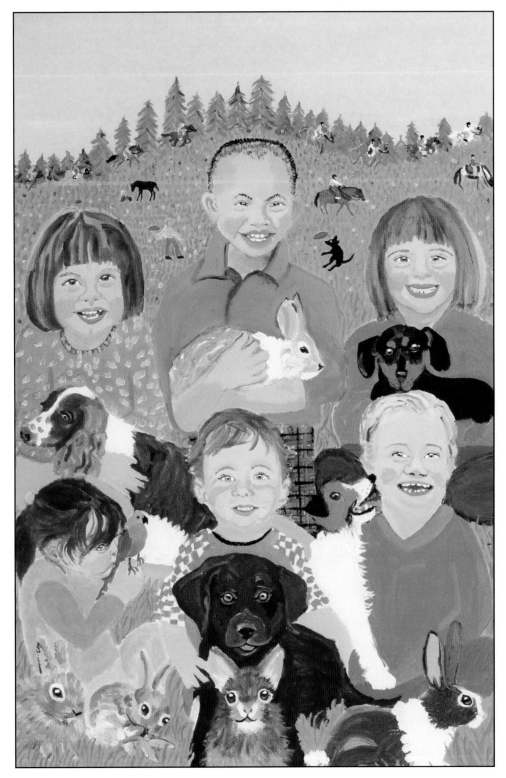

Bear Collage by Taylor Patrick Peters

Taylor Patrick Peters is 14 years old and lives in the country outside of Mellen, Wisconsin, in the northern part of the state, close to Lake Superior. He is the proud uncle of fourteen nieces and nephews, and also has two parents, an older brother, three stepbrothers, and one stepsister.

Taylor's interests include art, swimming, snowshoeing, sliding, and hiking. He loves playing Xbox, especially racing games. As reflected in his artwork, Taylor has a special interest in bears. He has made many trips to the International Bear Center in Ely, Minnesota, with his family.

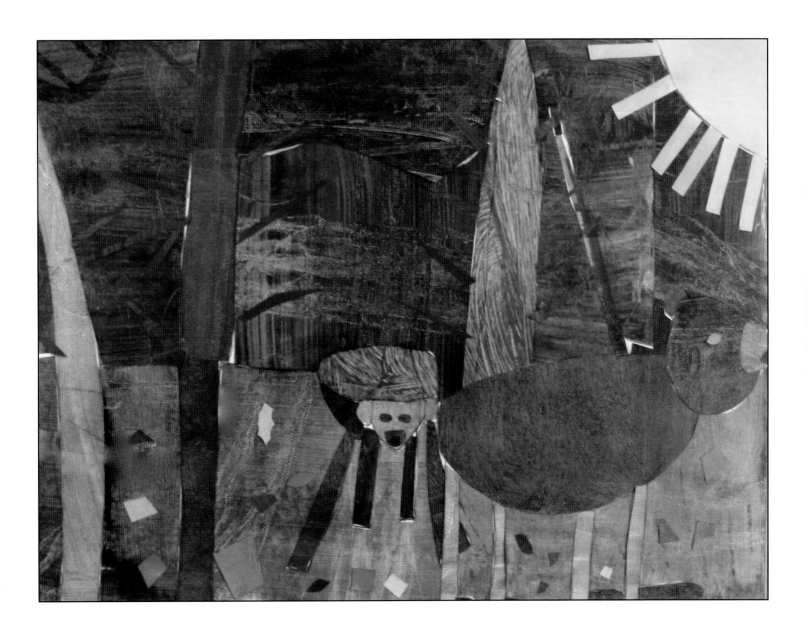

Eliza Schaaf, 22, is an Oregon native who loves all types of art—
painting, drawing, ceramics, fiber arts, and photography. She first
became interested in art while attending a small school called
Pinehurst in kindergarten through eighth grade. Recently, she took a
ceramics class at Southern Oregon University.

In November 2011, Eliza spoke as a keynote panelist at the
State of the Art Conference on Post Secondary Education and
Indviduals with Intellectual Disabilities held near Washington, DC.
She hopes to speak at other colleges and share about her dream
to go to college and study art, writing, and filmmaking. Last year,
several filmmakers came to Oregon to do a film project about Eliza,
which was an amazing experience for her. She has made some great
new friends showing the film, *Hold My Hand*, speaking, and showing
slides of her art at schools around the country.

When she is not creating art or giving presentations, Eliza likes
to hang out with friends, cook, work out, enjoy nature, dance, listen
to music, and watch movies. In the fall of 2012, she was accepted
at Highline Community College in Des Moines, Washington. She is
excited about studying printmaking, writing, photography, ceramics,
and maybe filmmaking in college with her peers.

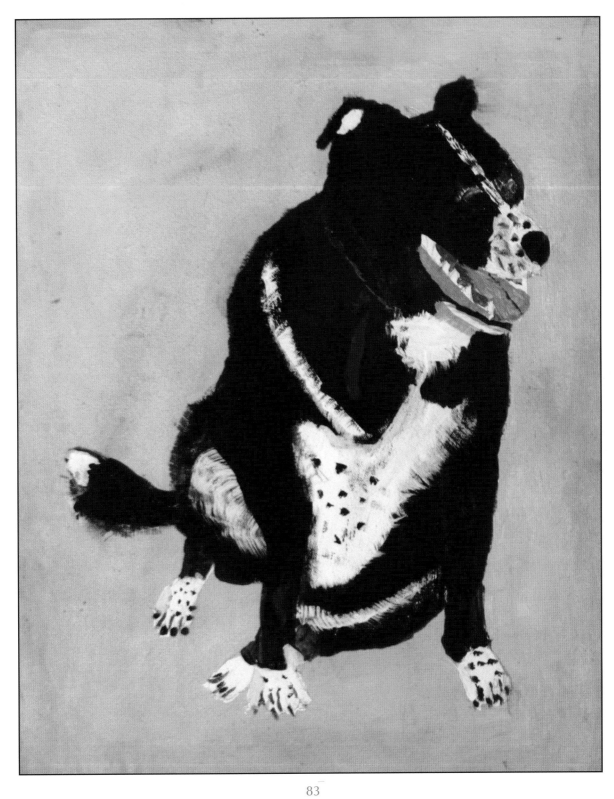

Porcupine by Heidi Schroder

Heidi Schroder, 34, lives in Niskayuna, New York, and is employed part time at the Center for Disability Services Commercial Services and Adult Services Programs in Albany.

Heidi has been an art student at Living Resources Carriage House in Albany for six years and has sold several paintings. Her porcupine painting was featured in Living Resources' 2010 calendar and won second place in the Cerebral Palsy Association of New York's annual poster contest and first place in the Center's annual art contest. In 2010, Heidi's *Squirrel* won the Spirit Award at Voice 7! Annual Juried Exhibition at the State University of New York in Oneonta. Heidi was also chosen as a winner in the 2011 Down Syndrome Footprint Artwork Competition.

Heidi is a member of the Schenectady Chapter Special Olympics swim team. She has won numerous medals, including a gold and a silver in the 2012 New York State summer games in Buffalo. She has also been involved in horseback riding since elementary school and is a dedicated, accomplished equestrienne.

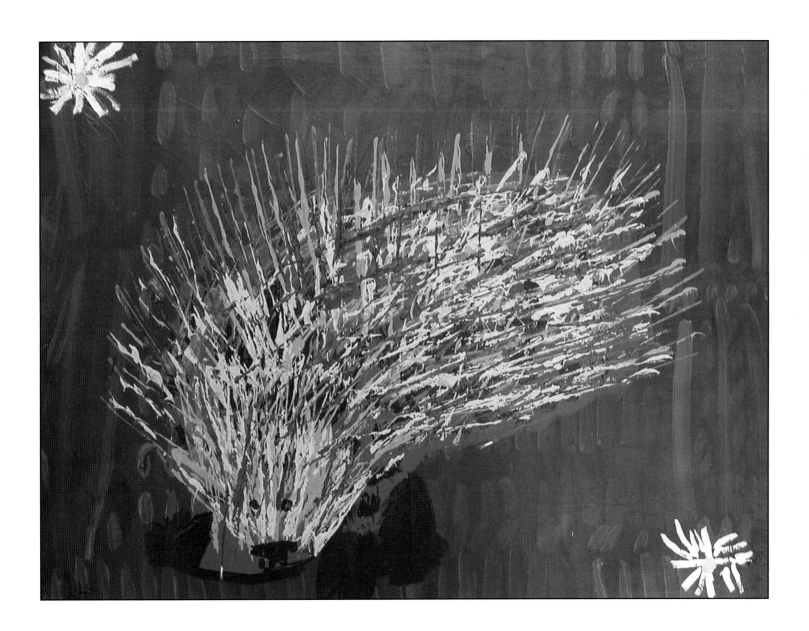

Squirrel by Heidi Schroder

Heidi Schroder's biographical note is on page 84.

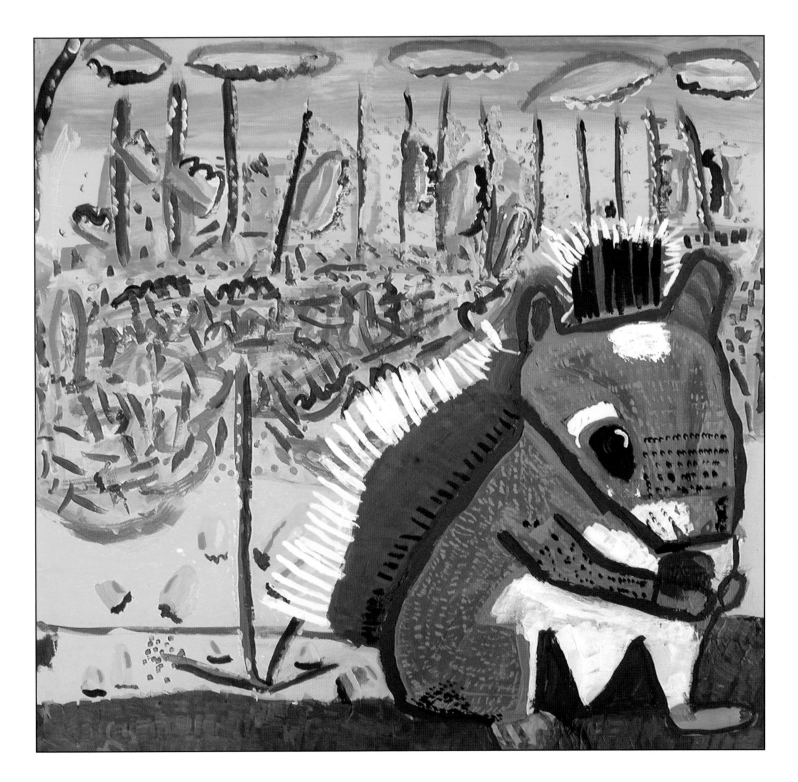

Wildebeast by Heidi Schroder

Heidi Schroder's biographical note is on page 84.

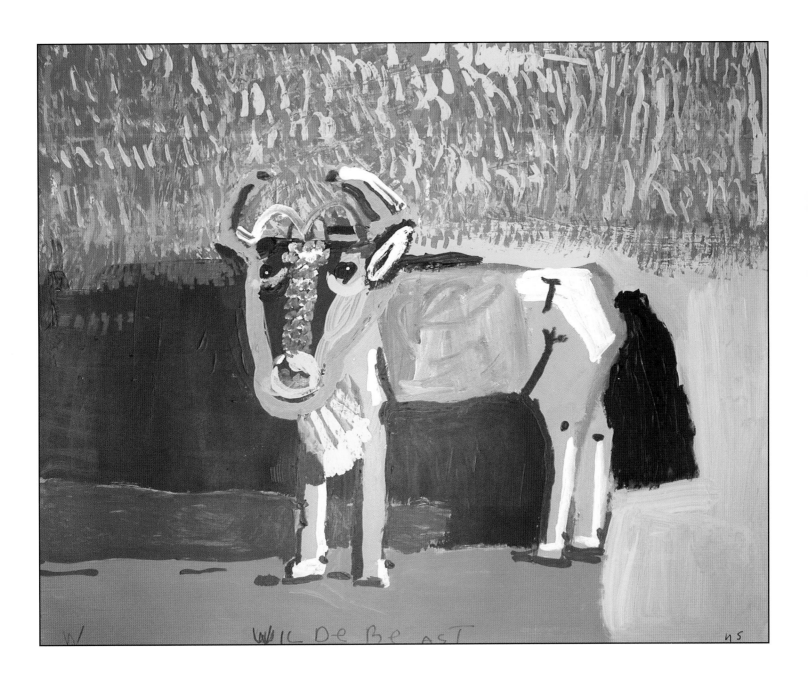

W WIL De Be asT 45

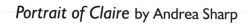

Portrait of Claire by Andrea Sharp

Andrea Sharp's biographical note is on page 24.

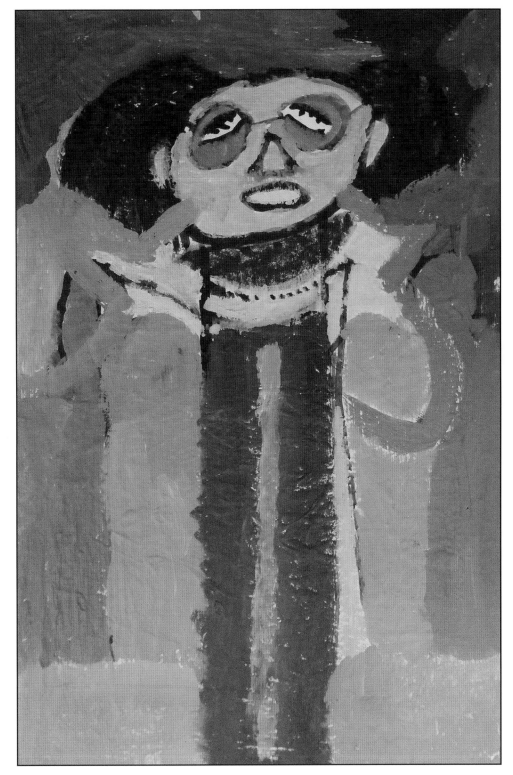

Wendy Weisz grew up in a big family with a love of art and books. Now 43, she lives with her parents in Ohio and sees her siblings and their families often. She often travels with her family, camping in Ontario every summer, bird watching and dancing to country-western music in Texas in the winter, and visiting many National Parks. She also went to Spain after her high school graduation.

Wendy usually paints from the photos she takes on her family's trips. Her favorite medium is oil, but she also likes acrylics. She has taken courses in drawing, painting, ceramics, and sculpture at her community college, and has also taken painting classes at a local art center for almost twenty years. Wendy has always loved drawing—when she was ten, one of her pictures was in a National Down Syndrome calendar.

Wendy makes hand-made greeting cards at the local adult activity center. Some of her paintings have been used for holiday cards, and one of them was chosen by the HeARTworks Gallery and was printed on mugs and mouse-pads. When not working or travelling, Wendy enjoys going to church and helping out there, cooking, and going to picnics and dances with friends. She also likes to do Reiki—hands-on healing—to help her family and friends with aches and pains.

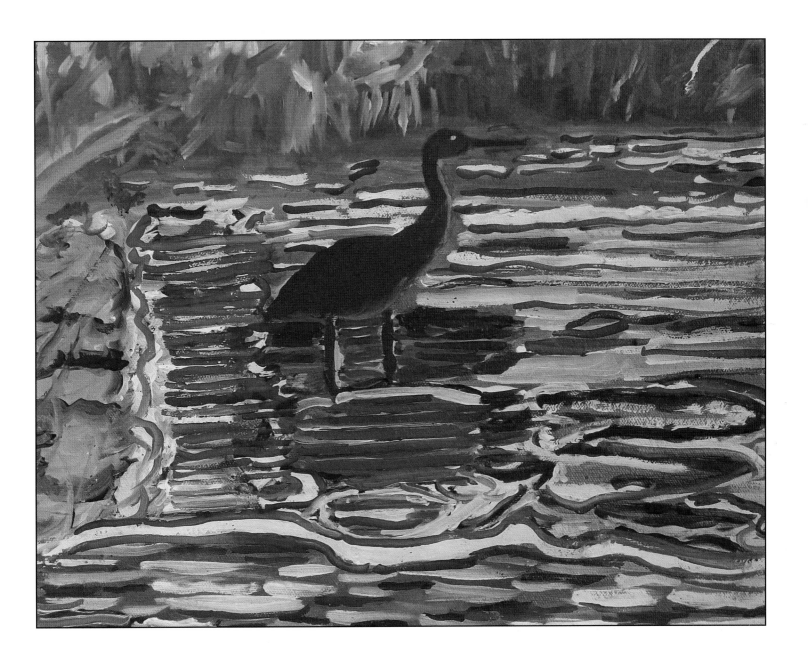

Carol'Ann M. Alphin, 44, has lived in Hagerstown, Maryland, all her life. For several years, she worked at McDonald's, but she had to retire after she got carpel tunnel syndrome. She now volunteers at many different places, including nursing homes, Children In Need, the school office, Sunday School and Bible School, day camps for special needs children, and as a practice patient for X-ray students at the local college. She is also an active member of Longmeadow Lions Club and helps with many fundraising activities.

When she is not volunteering, Carol'Ann attends a day program at the ARC, and also enjoys writing poetry, visiting the library, cooking, listening to music, painting with water colors, and making cards to give to nursing homes and friends. Sometimes when she is writing poetry she gets writer's block, but other times it just comes out.

Carol'Ann and her family have traveled out west many times to visit her mother's family, by air and by motorhome, and have also traveled to many countries. Carol'Ann's mother says she is an Ambassador for Down syndrome because everywhere she goes, she meets many people and sometimes they come up to her and talk about Down syndrome.

Note: The Flash referenced in Carol'Ann's poem was her grandmother's pet collie.

Gramma

Carol'Ann M. Alphin

You took care of me when I was a baby.
You'll always be my favorite lady.

You helped me learn to walk and talk
And even how to snap my fingers.
You babysat for Cindy and me,
Though sometimes we were little stinkers.

Sometimes you picked me up when I got home from school.
You always kept Cindy and me from having a duel.

We did my homework in a dash,
Ate some pudding and played with Flash.

In the summer, we liked to swing or played with dolls for hours;
But we always had time to look at your flowers.

On Sundays, we went to church a great deal.
Then we went out for a favorite meal.

We still like to have our afternoon tea,
Look at the birds and squirrels and watch TV.

You will always be a great part of me,
'Cause when I'm happy or sad,
You are always there for me.

There's so much more that I could add to this page;
But I'll leave that for another age.

Love, your lovely granddaughter, Carol'Ann Alphin
On Your 75th Birthday, April, 1990

Danielle Elizabeth Barry, 23, is a Virgo and a native of Schaefferstown, Pennsylvania. She has been writing poetry since she was 12, and has won a poetry contest sponsored by her local library. She has also gathered many of her poems and stories on spiritual themes into a book, which she has sold to fellow parishioners at Mary, Gate of Heaven Church. The local Catholic Witness paper has published an article about her achievements.

In addition to writing, Danielle's interests include talking to God, photography, gardening, dancing, playing the guitar, horseback riding, collecting seashells, reading, and Mother Nature. She has been involved in Girl Scouts, music class, bowling leagues, gymnastics and other sports, fashion shows, and talent shows of solo dancing.

Danielle graduated from the School to Work program in 2011, and since then has been working full-time.

Girl You Beautiful
(To All Girls)

Danielle Elizabeth Barry

girl you
you are beautiful,
beautiful
no matter what shapes, sizes and how you look
you
still beautiful even if they pick on you still
beautiful
don't let anyone tell you that you are not
because you dare

girl you are
beautiful, beautiful

you just let it show and who you are
people can like you the way you are
makes who you are deep down inside

we girls, we show the gift how we look and dress
we know how guys think and we are not afraid how we look
looks are not everything
just show who you are
that's the only look you need to worry about

we girls, we are special in every way
just be you that's how we make friends
just be yourself and they will like who you are
inside and outside

girl you are
beautiful, beautiful

If you want friends you must be a friend
friends are friends until the end
now remember you are
still beautiful in the heart inside and outside

girl you are
beautiful, beautiful

we just have to show it
people can like who you are
that's how we get friends
girl you are
beautiful, beautiful

So Many Butterflies
Danielle Elizabeth Barry

colorful and different
wings covered with colorful scales, markings and patterns
in the spring and summer
butterflies turn out and show
their colors off to the world, off in the great outdoors

so many butterflies
with colors, markings and patterns
skipping across each nectar plant and flower
in this great outdoor life
so many butterflies out there
landing on the flowers of so many colors

butterflies grow so unique and gorgeous
in the spring and summer
all so fun to look at
watching them and taking photos
what an enjoyment

admiring their beauty is a passion of mine
so many butterflies out there
with colors, markings and patterns
admiring their beauty

Adrian Drower, 23, works and volunteers seasonally at the Chicago Botanic Gardens. He spends a lot of his free time writing poetry, lyrics to songs, and stories. Besides writing, he enjoys reading, working out, musicals, plays, and hanging out with his friends. A self-professed oldies fan, he often listens to the Beatles, Buddy Holly, Bob Dylan, Frank Sinatra, and many, many more. In addition, he enjoys watching many different types of movies and playing video games, and he can swim like a fish.

Thanks to his grandfather, Adrian owns a car. He has had his license for about five years and loves driving. His favorite season is winter because he enjoys the white wonderland scene. He notes that he is always able to find the good in almost anything or anyone.

Brothers
Adrian Drower

From fist – to - fist, or with voice,
Brothers tease, taunt, fight, each other.
Dull moments are a choice,
In the life of any brother.

Being rude or calling names,
Always get each other in trouble.
With their smells they place blames.
Parents punish by the double.

They always hang out,
They might have highs and lows,
Do they ever have doubt?
Are they really foes?

They have a strong clear mind,
And listen to the call of the dove.
They are in fact very kind,
Their hearts—full of love.

Daniel Walker Jordan lives in Tallahassee, Florida, and is 26 years old. He enjoys collecting movies, creating artwork, and writing stories and poems.

As a Special Olympics athlete, Daniel has earned medals in bowling, basketball, and tennis. He was named Leon County's Special Olympics Athlete of the Year for 2012. During basketball season, Daniel is proud to be the manager of the Lawton Chiles High School varsity team, a position he has held at his alma mater for ten years. Daniel is also a first degree black belt in Kenpo Karate, a sport he has been involved in for thirteen years.

For the past three years, Daniel has worked at Westminster Oaks, a retirement community. There he helps in the dining room and joyfully volunteers with residents' physical therapy sessions.

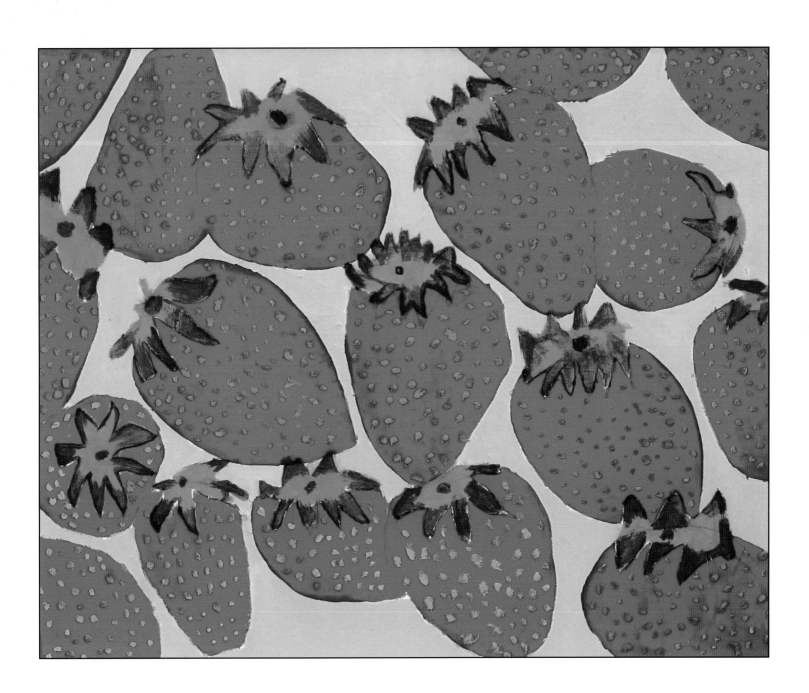

Chocolate Strawberry Cake by Tina Condic

Tina Condic's biographical note is on page 58.

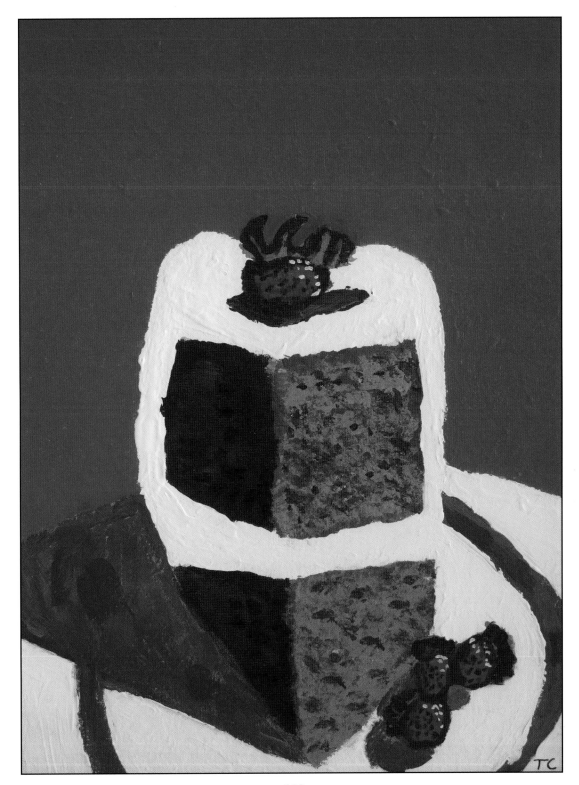

113

Emily Dodson's biographical note is on page 62.

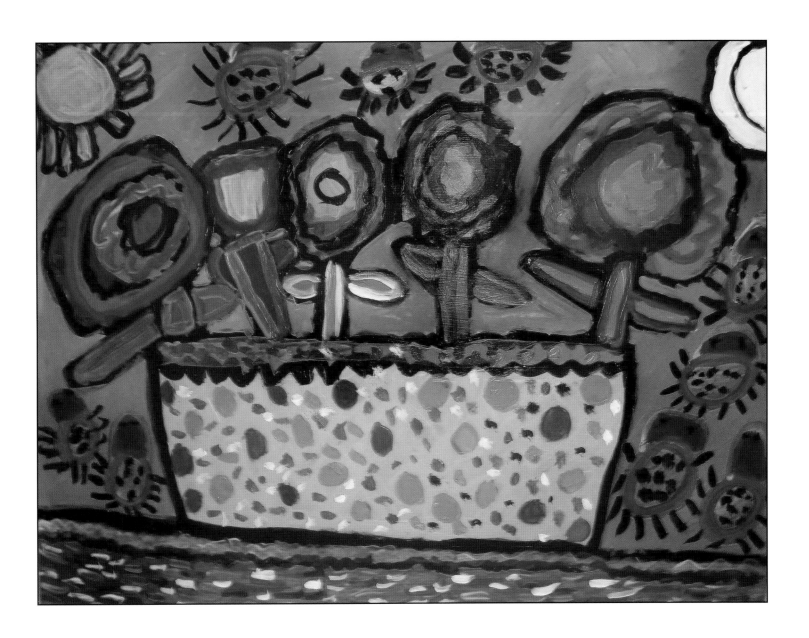

Wagon Wheel by Marissa Erickson

Marissa Erickson's biographical note is on page 6.

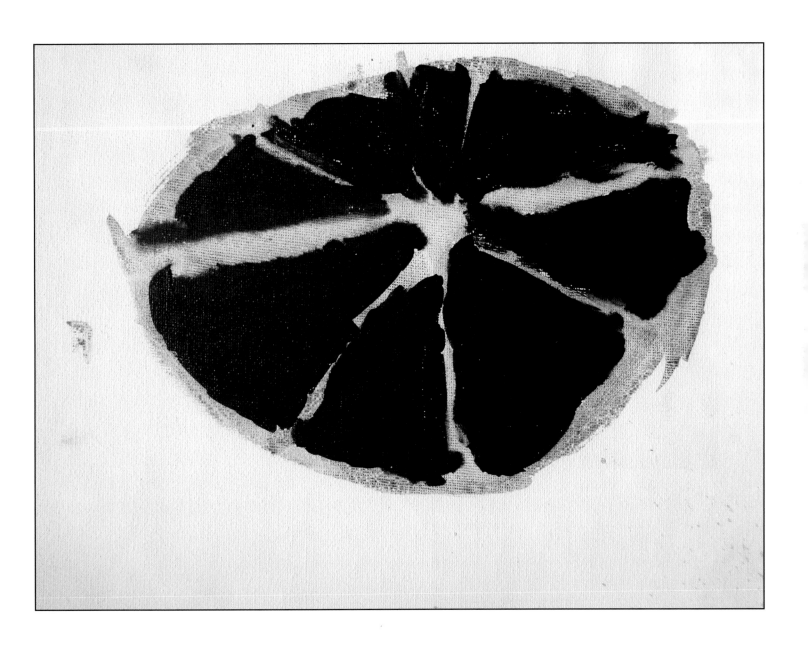

Angela Green, 45, was born and raised in Arkansas. For nearly half her life, she has been with Life Styles, a nonprofit in Fayetteville, Arkansas, serving adults with developmental disabilities. Life Styles has helped her find a home, as well as staff to help her with grocery shopping and housekeeping chores.

Angela attends art classes, where she has developed her own style involving a lot of primary colors and stark white faces. She likes to look at famous artists' paintings and paint what she sees. She also enjoys sewing.

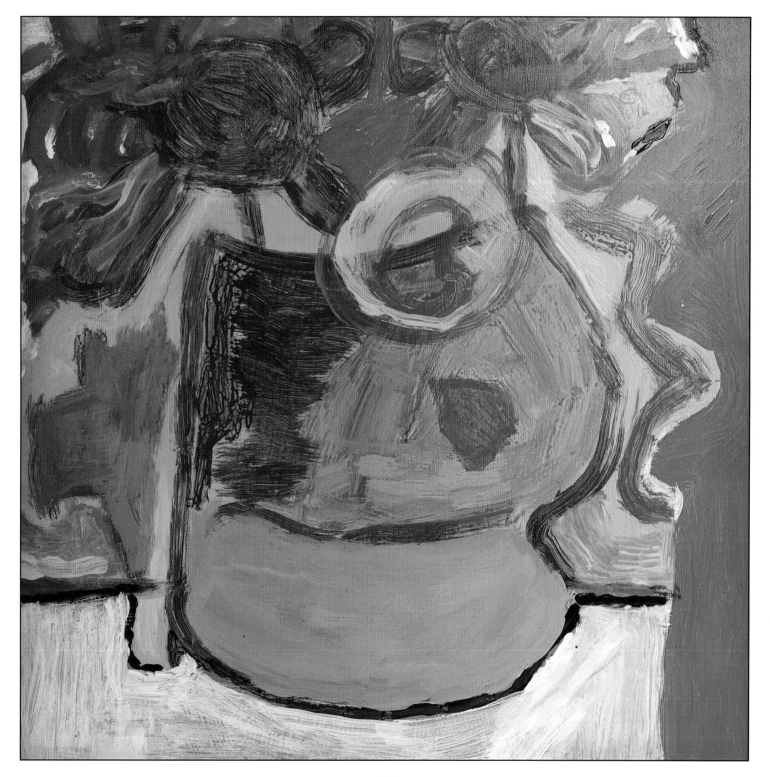

119

Autumn Leaves Falling Off the Plant by Angela Green

Angela Green's biographical note is on page 118.

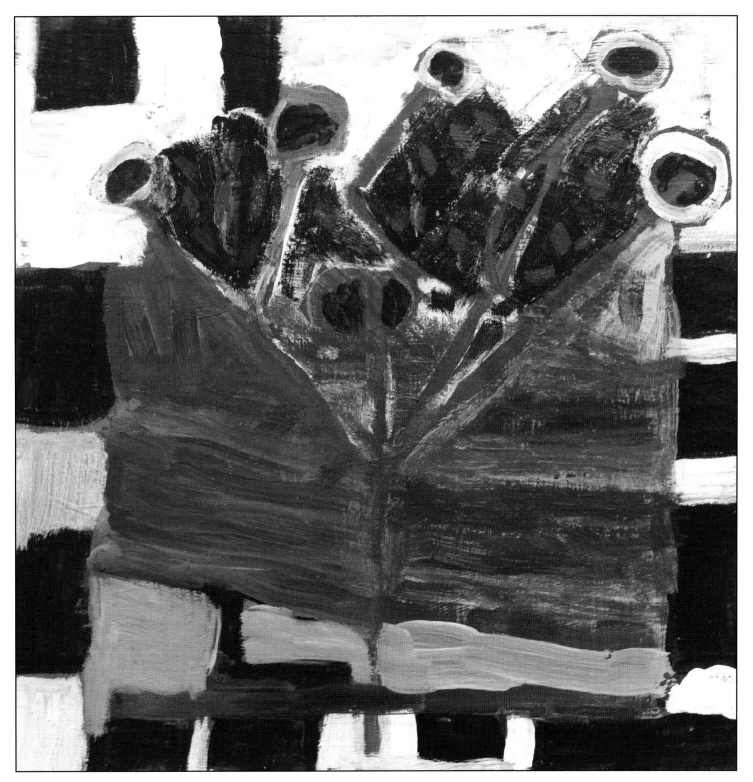

Vase Collection by Christine D. Maxwell

Christine D. Maxwell, 36, lives in Evanston, Illinois. She is a graduate of the National Louis University PACE Program with a Prebaccalaureate Certificate, as well as a recipient of the Distinguished Alumni Award from National Louis University for accomplishments after graduation.

In addition to sketching and painting, Christine has a passion for guitar, travel, Zumba, tai chi, and spinning. She has been involved in Special Olympics for twenty-five years, earning a Gold Medal in Gymnastics at the 1999 World Games in North Carolina and speaking often as a Global Messenger.

Christine has been employed at Cinemark Theatre for twelve years, and is therefore qualified to be her family and friends' favorite movie critic. In 2010, she served as Co-Chair of Advocate Lutheran General Hospital's 2010 Gala supporting the Adult Down Syndrome Center.

Christine's awards include the Schaumburg School District 54 Outstanding Alumni Certificate, as well as the National Down Syndrome Congress 2010 Christian Pueschel Memorial Citizen Award for enhancing positive awareness of Down syndrome through outstanding personal achievements.

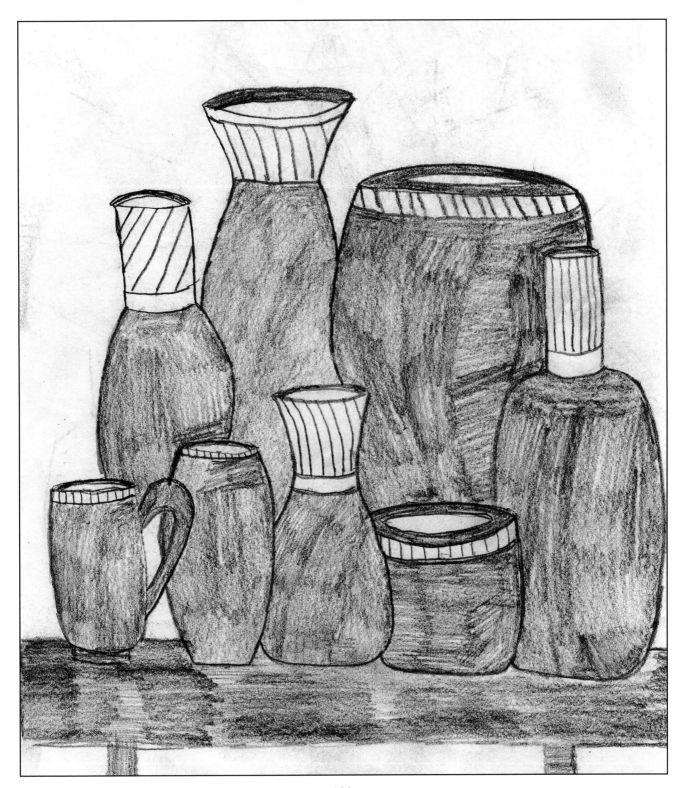

Rosa by Christina Remson

Christina Remson is 25 years old and lives in Brentwood, California. She started her artistic career classically trained in watercolor by two talented artists, Jenny Floravita and Teresa Ochoa. She has since moved on to painting with acrylics, and is currently taking classes with artist Trisha Padama. The new medium, along with her technical skills and enthusiasm, allows her to be successful.

Christina prefers to use a realistic style with loose brushwork. She is inspired by the trips she has taken, nature, dogs, friends, and her loving family.

Besides painting, Christina enjoys doing Zumba at the gym, bowling, and going to the movies. She is also a big Disney fan and a lifetime member of Weight Watchers. In addition, Christina volunteers with the Kiwanis International's Aktion Club of East Contra Costa County, as well as at a local senior center, where she helps the residents participate in Richard Simmons exercises and Zumba.

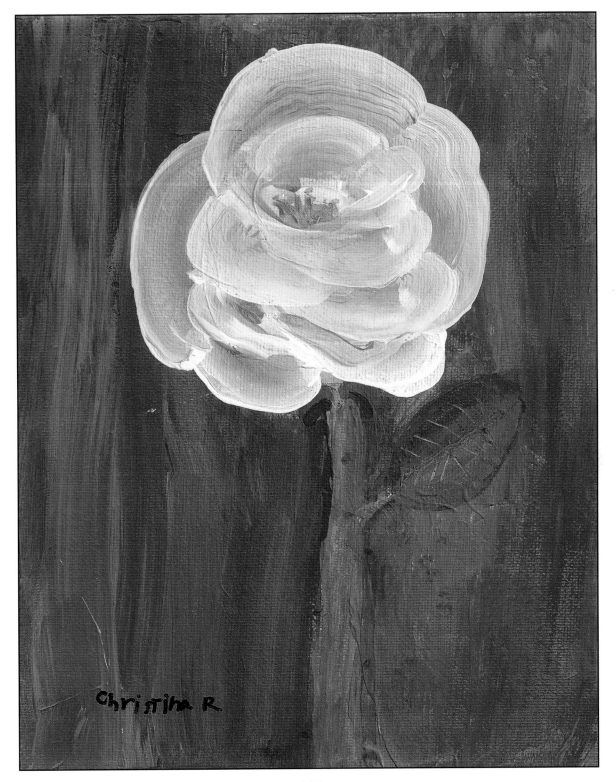

Christina Remson's biographical note is on page 124.

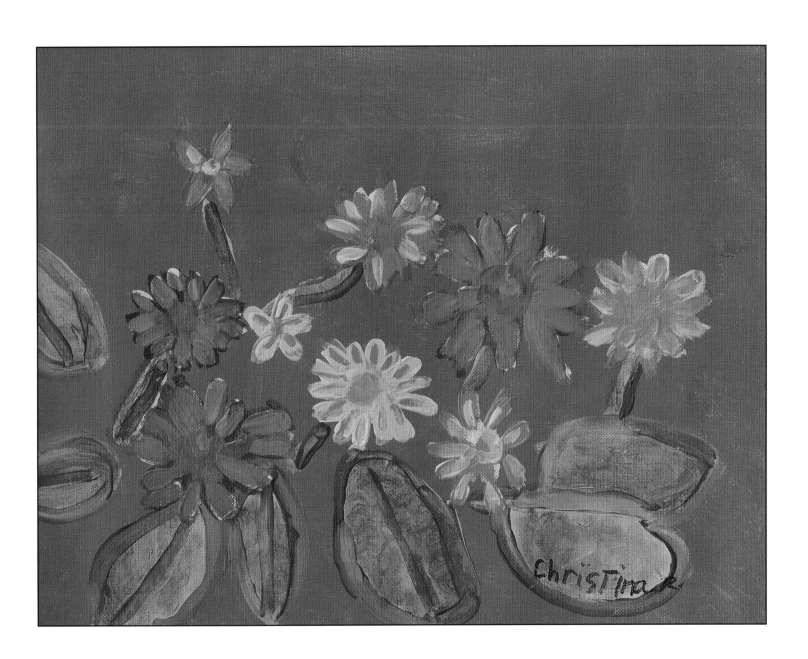

J.C. Watts, 21, grew up in rural Norwalk, Iowa. He graduated from Martensdale—St. Mary's High School, where he took art classes for four years. This is when J.C. did most of the art in his collection, trying many different kinds of mediums. He has worked with clay and also enjoys acrylic painting.

J.C.'s "Painting Tray" was displayed at the Iowa State Fair and various other locations in Iowa as part of the Governor's Very Special Arts Program. In the summer of 2011, he took a drawing and painting class through the Park & Recreation Department, and would like to try more classes in the future. He hopes someday to have his own art studio, where he can work on adding to his collection and selling his work.

J.C. currently shares a house in Indianola, Iowa, with three roommates and a cat named Alan. He works five days a week at Genesis Commercial Laundry and spends his free time participating in Special Olympics, going to movies, bowling, or eating out at his favorite restaurants. Besides doing art work, he likes to read, play video games, and collect YuGiOh cards.

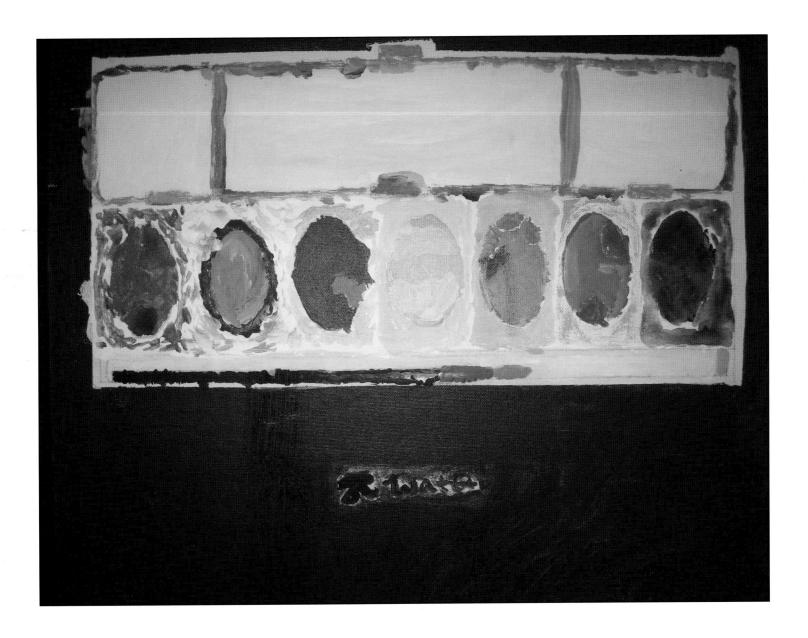

Meghan Zellmer is a 22-year-old resident of Inver Grove Heights, Minnesota. Meghan loves to draw, using lots of colors, and often works on her art while watching movies at home. She took several painting and multimedia classes in high school and continues to enjoy creative art projects.

After graduating from the Dakota County Technical College transition program in June 2011, Meghan began working at ProAct. At ProAct, she is learning job skills and getting paid. Her dream job would be to work with animals, especially dogs. She is also taking classes in theatre and swimming at ProAct, and volunteers at Feed My Starving Children. She recently moved into an apartment with her friend, Katie.

Meghan belongs to a group called the Highland Friendship Club, and, with her fellow club members, has made two movies—"Romancing the Force" and "Pyrates of the Mississippi." Meghan enjoyed memorizing her lines, as well as singing and dancing in the movies. Meghan also plays piano.

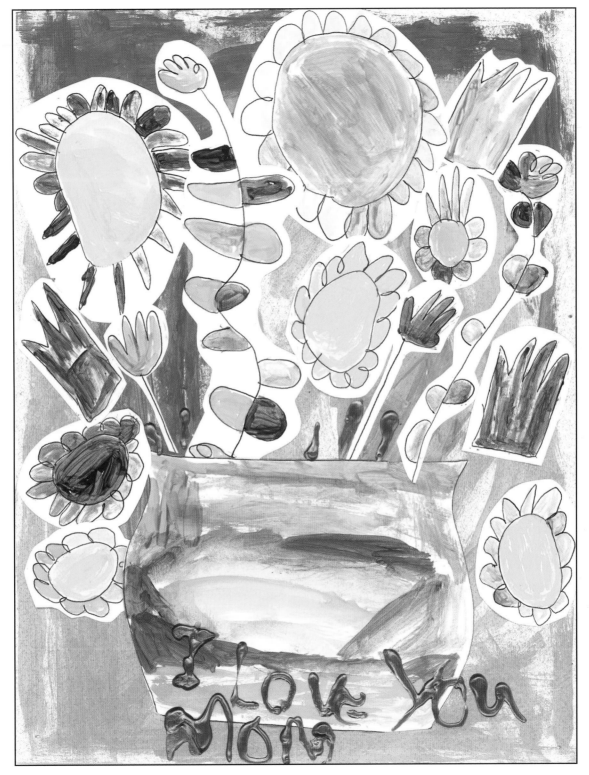

Debbie Chandler, age 50, has loved words and reading since she was a child. She has written so many poems she can't begin to tell you how many. She can't really define what kind of poet she is, but she is willing to try different types of forms in writing poetry.

Debbie has previously had a poem published in a newsletter where she volunteered and liked seeing her name in print! Like many writers, she sometimes has writer's block, but hopes to devote more time to writing soon.

Debbie is a Texan and a high school graduate (class of 1980). She has also participated in a non-academic writing class at her local two-year college, where she did well. She is an avid reader who fellowships at a Christian church. She is the oldest in her family, has a sister who is two years younger, and is an aunt five times over, as well as a great aunt.

The Hand That Reaches Down to Help Me

Debbie Chandler

Several times when I feel down and depressed a hand reaches down to help me. Through the dark hours of depression I see his hand reaching down to guide me.

He smiles patiently when I stumble through life's troubles. He picks me up when I fall. He gently tells me not to worry about simple things. He sits with me at night and we talk about the future.

I know without his hand I couldn't make it through life. His hand is strong when he picks me up. His hand is gentle when he is compassionate.

Where would I be without him? I'd be no where without his existence in my heart.

I feel like going on.

Stefan Xidas, age 24, is an avid songwriter and singer who lives in Wilmette, Illinois, with his family. Stefan writes lyrics every day and enjoys the songwriting process. His most notable claim to fame was singing the national anthem at a Chicago White Sox game in 2005, the year they won the World Series.

Stefan comes from a very musical family. His great-grandfather, grandfather, and father, as well as his two brothers, are all musicians. His favorite style of music is country and his favorite artist is Kenny Chesney.

Stefan is also a skilled tennis player. He has been part of the Special Olympics tennis program for the last 10 years and has medaled at many tennis events. Stefan currently works at Target and Lou Malnati's Pizzeria in the Chicago area. While he loves both of these jobs, his true passion is the writing of "the song."

In Your Shoes
(Song)

Stefan Xidas

Verse 1:

 Have you ever been outside?
 You wore steel clothes to keep dry
 It's raining cold winds blowin'
 Beggin' and pleading you cry
 You had your hard knocks outside
 I wouldn't know how to be in your shoes

Chorus:

 In your shoes
 Have you been where he'd been on the sidewalk?
 It's pouring out on the pavement under the bridge where he sleeps
 He can bear with this anyway he can but, it sure gets him down
 He hears the rain coming down and the thunder roars
 I'm a Christian. I'm God's child. I've seen the light and God calms the storm
 I wouldn't wanna be
 In your shoes

Verse 2:

 Have you ever been poor and proud?
 Have you ever heard the preacher say
 "We're all God's people under the skin"?
 He's poor, he's a Christian and he believes
 He talks to God like he is talking to a friend
 You are merciful. Can you grace him, he's your child too
 I wouldn't wanna be
 In your shoes

(Repeat Chorus)

Chorus Reprise:

 I'm a Christian. I'm God's child. I've seen the light

 God calms the storm. You are merciful. Can you grace him one.

 He's your child too. I'm your child too, oh yeah. . . .

Let's Not Say Goodbye
(Song written to friends for High School graduation)

Stefan Xidas

Verse 1:

 While you're off doing your thing

 I'll be doing mine

 I guess I'm left here all alone

 And I don't want to say goodbye

 'Cause I love you so

 Gonna miss you both

 Let's not say goodbye

Verse 2:

 I'm really gonna miss those times

 Just hanging out and sharing laughs

 No matter what the future holds

 We'll share a smile when we look back

 Man, those were the days

 Wish they'd never change

 Let's not say goodbye

Chorus:

> Let's say so long, see you later
> I wish you well wherever life takes you
> No need to say farewell, we'll be fine
> Let's not say goodbye

Verse 3:

> We're all for one and one for all
> Like brothers we were always close
> And hanging with my two best friends
> I guess that's what I'll miss the most
> Oh, our glory days, wish they'd never change
> Let's not say goodbye

(Repeat Chorus)

Bridge:

> Swimming in the backyard pool
> Sunday dinners and nite league ball
> Tommy's old home movies, we'll remember it all. . . .

Final Chorus:

> Let's say so long, see you later
> I wish you well wherever life takes you
> No need to say farewell, we'll be fine
> Let's not say goodbye

Allison Renee D'Agostino, 23, was born in South America and spent the first four years of her life in Bolivia with her parents, who were missionaries at the time. After her parents' divorce, Allison was raised by her mother. Today, she credits her mother with helping her become the woman she is today—a strong, independent woman who lives on her own (with some help). Allison is now in an amazing relationship with the man she believes she is truly destined for. She states: "He and I have gone through a lot, and will go through even more—but together. What is life, though, without some obstacles?"

Allison now lives in Mid-Missouri and has a passion for writing books, songs, and poems; getting together with her family, dog, or friends; and exercising/playing on her Wii. She has performed one of her songs, but would rather sing karaoke. Her father's side of the family is musically talented, so she has a natural singing ability and can also play the piano, even though she has never had any formal lessons.

Guilty as Charged

(Song)

Allison Renee D'Agostino

They say you got nothing on me.
You got nothing to prove me guilty.
Well, I know they got one thing wrong.
Something must be said. Something must be done.

I'm guilty for loving you so.
There must be a crime for having a heart.
(Speaking) Here it is. I'll give you the gist.

(Chorus)
Lock me up. Throw away the key.
Give me the cuffs. Give me the guillotine.
I must be going out of my mind.
I can't take this pressure anymore.
I'll say it right now.
I'm guilty for loving you so.

It's something that can't be broken.
Whether I'm gone, or whether I'm right here.
So come on. What are you waiting for?
'Cuz one thing's certainly true.
I'm guilty for loving you.

Lock me up. Throw away the key.
Give me the cuffs. Give me the guillotine.
I must be out of my mind.

I can't take this pressure anymore.
I'll say it once more.
I'm guilty for loving you so.

I know my love is true.
Every time I see your smile,
I melt inside, like a popsicle.
Every time I feel your touch,
I feel safe and want to stay with you.

Lock me up. Throw away the key.
I'll take the charges with my pride.
'Cuz one thing's certainly true.
My love for you will never die.

My life was such a bore.
(Thank you for entering it.)
I had such difficult times.
I thought I'd never find real love.
Until I met you!

Thank you for waking me up.
Thank you for telling me those words.
Thank you for talking to me.
Thank you for setting the spell.
Thank you.

(stanza repeat) Thank you for waking me up.
Thank you for telling me those words.
Thank you for talking to me.
Thank you for setting the spell.
Thank you.

(stanza repeat, more freely) Thank you for waking me up.
Thank you for telling me those words.
Thank you for talking to me.
Thank you for setting the spell.
Thank you.

I'll be waiting right here . . . for you and your love.

Tina Condic's biographical note is on page 58.

Austin Davenport's biographical note is on page 60.

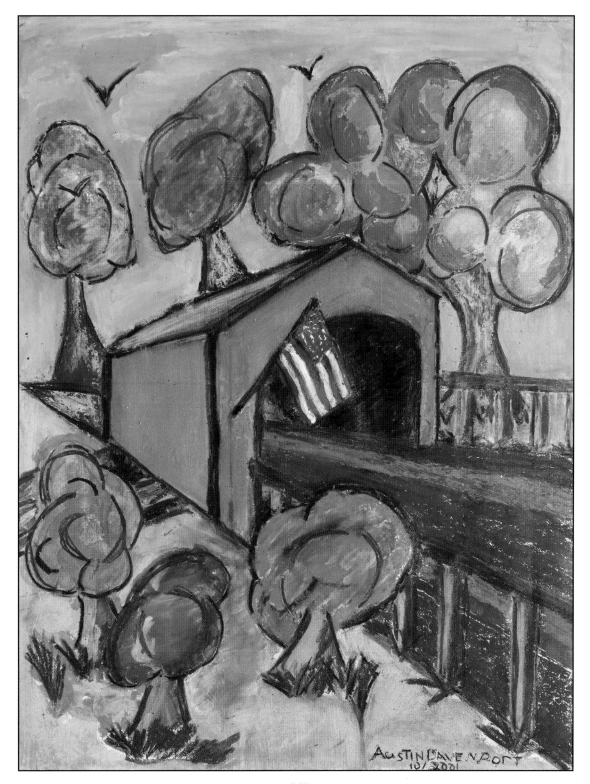

Fenway Park by Elizabeth C. Knipstein

Elizabeth (Beth) **C. Knipstein,** 29, has always loved art. She took all the art classes she could in school, and used art to express what she knew, illustrating her book reports and history assignments. After high school, she attended the Center for Emerging Artists, where she painted the Fenway Park painting for her brother, Bob. She is one of the three artists featured in a documentary, *Three Paths*, produced by the Center for Emerging Artists, and has had newspaper articles written about her and her work.

Beth now attends Gateway Arts (www.gatewayarts.org), a program for artists with disabilities, and had a piece on exhibit at Barney's New York for their Christmas display on Lady Gaga. At Gateway, she makes jewelry and pottery, weaves, paints, and draws in half-day studios five days a week.

Beth taught art to preschoolers one day a week at the Learning Discovery Center in Saugus, Massachusetts, until it closed in November, 2012. She hopes to get another teaching job soon. Art is her life!

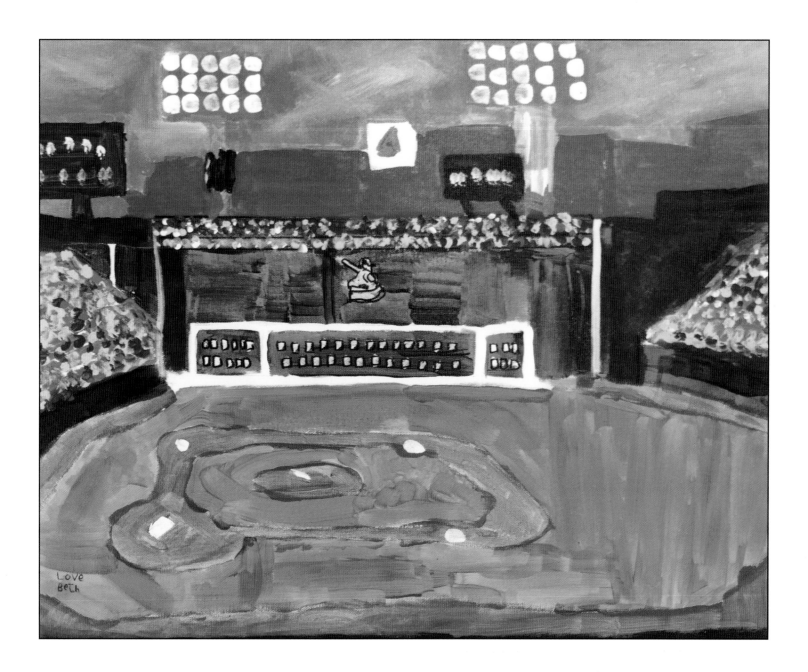

Amsterdam: Windmills by Dylan Kuehl

Dylan Kuehl (pronounced Keel) is a life-long resident of Olympia, Washington. He has used art to express himself since attending kindergarten at the Olympia Waldorf School. Able to speak only three words, he used beeswax crayons to express himself. Over the next 25 years, his language advanced, and so did his art.

In elementary school, Dylan enjoyed drawing pictures for posters. He especially liked dinosaurs at the time. In high school, Dylan took pencil drawing and watercolor painting. Since completing public school, Dylan has worked with several local artists. For five years, he took private art lessons from Dorisjean Colvin, a world-known pastel painter and instructor now in her eighties. She taught him the art of soft, hard, and oil pastel painting, along with what it means to be a "professional artist."

Dylan is also a motivational keynote speaker and has traveled to Italy, Ireland, and Amsterdam. While there, he took hundreds of photographs, which he used as the basis of paintings.

2012 brought changes to Dylan's artistic world. He has temporarily put down his paint brushes and picked up his drumsticks. A dream come true, he is now the lead drummer in a band that plays music by Michael Jackson. Since putting down his paints, Dylan has been learning the art of working with fused glass. Each piece of his fused glass is custom made with a touch of dichroic glass that shines. His jewelry and other fused glass products are for sale at the famous Seattle Pike Street Market. His artwork can be seen on his website: www.dylankarts.com.

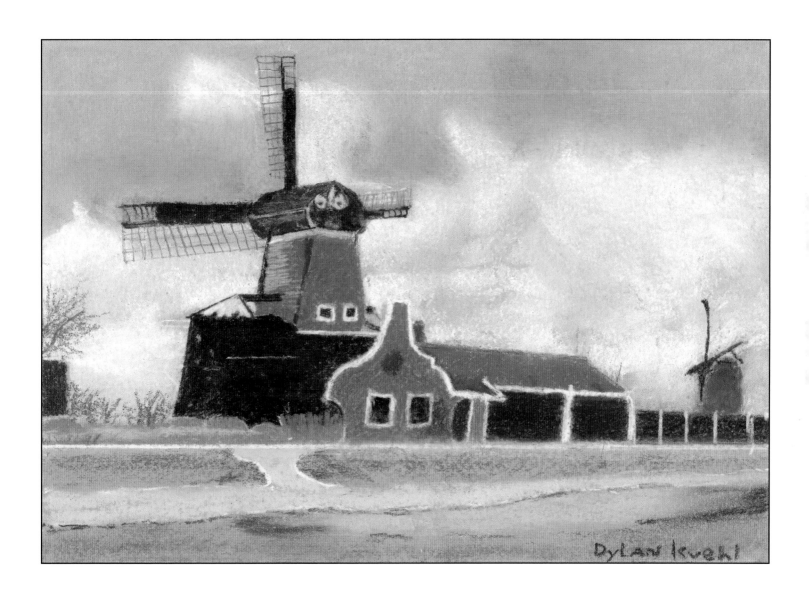

Dylan Kuehl's biographical note is on page 148.

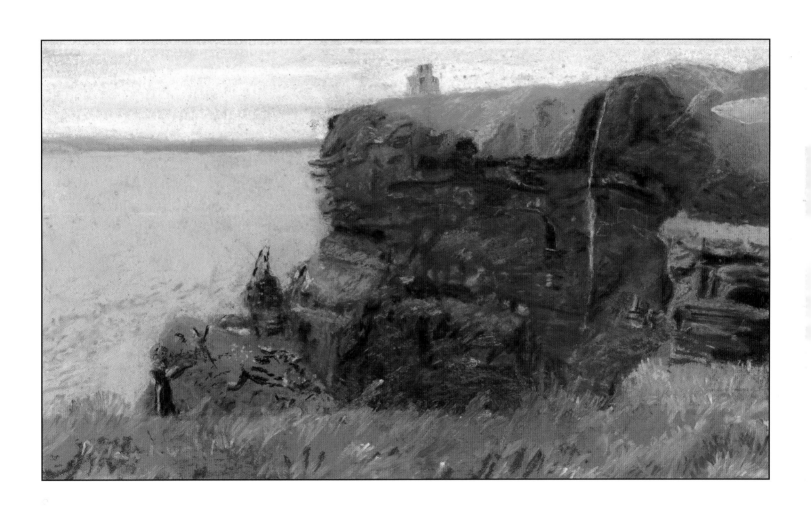

Italy: Lamp Post by Dylan Kuehl

Dylan Kuehl's biographical note is on page 148.

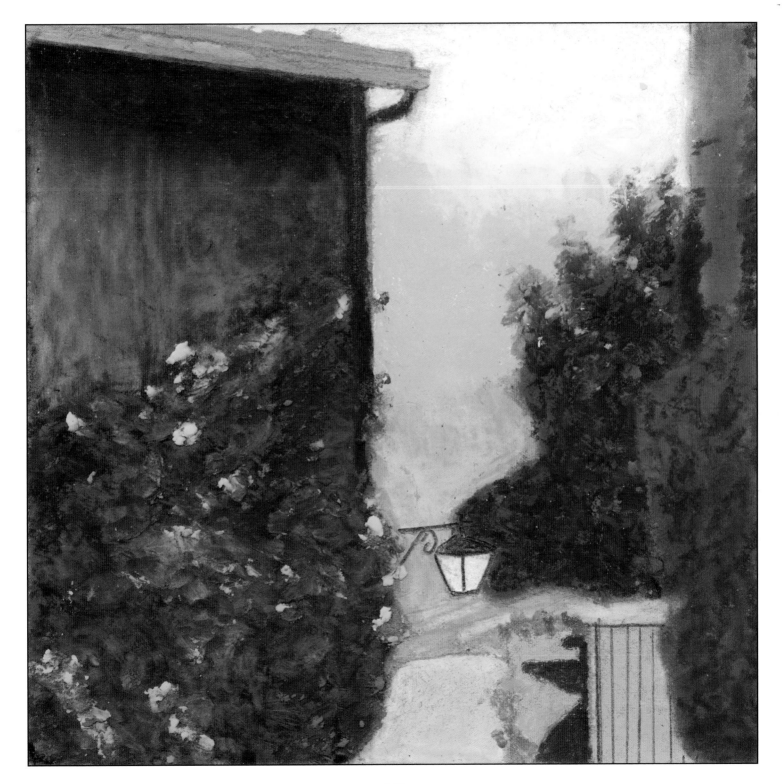

Connor R. Long was born in Montgomery County, Maryland, in 1994 and graduated from Fairview High School in Boulder, Colorado, in 2012. He lettered on the Fairview men's swim team and is a six-time medalist at Colorado Special Olympics State Aquatics Games. His involvement with the Mile High Down Syndrome Association, the Global Down Syndrome Foundation, and the First Presbyterian Church of Boulder led to joint recognition by the John Lynch Foundation and Anna & John Sie Foundations as an "Exceptional Star of the Year" for 2011.

After high school, Connor has begun to mash-together work-experience internships, theatre coursework with the Colorado Shakespeare Festival, acting projects, and generally being a good advocate, role model, and mentor to others. His film debut as co-star in the dramatic short film *Menschen* was released for the film festival circuit in 2012. Near-terms goals are to act in more film and theater projects, write more songs, develop martial arts and stage combat skills, continue to study and perform in the Colorado Shakespeare Festival, hone his "British," and eventually join the cast of BBC's "Merlin." Then he plans on sparking a revival of both Mighty Morphin Power Rangers and—his parents hope—Monty Python. Meeting Harry and Hermione, especially Hermione, would be brilliant, too. Connor is a founding member of the Tapestry Theatre, a local inclusionary-arts program in Louisville, CO, and a legislative advocacy "Ambassador" in Colorado for the National Down Syndrome Society (NDSS).

Connor's painting *Early First Snow* is a sophomore-year art class project depicting a scene in which rows of apple trees still bearing bright red fruit have been visited by an early-season snowstorm.

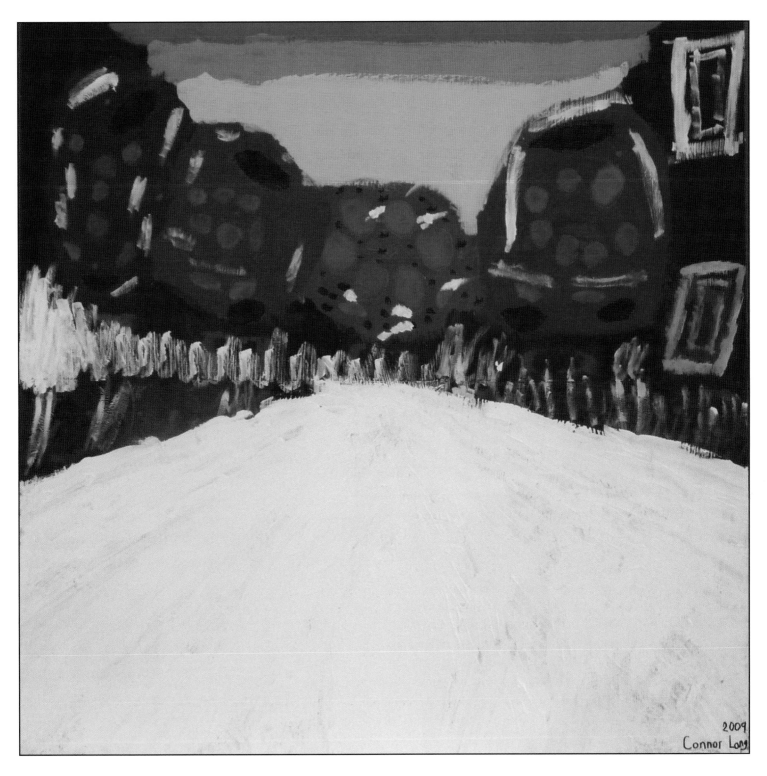

2009
Connor Long

Margaret Linnea Moore, age 33, was born in Japan but graduated from Springdale High School in Arkansas. She currently lives in her own apartment in the community, and hopes to get married in the future to someone special. In the meantime, she likes spending time with family.

Margaret enjoys drawing, sketching, and painting, in part because she loves the process of coming up with ideas and brainstorming. She is an expert gessoer (gesso is a liquid that is used to prime surfaces for painting). She also likes to collect leaves and other things from nature, so, not surprisingly, she is pleased that Margaret means pearl and Linnea means flower.

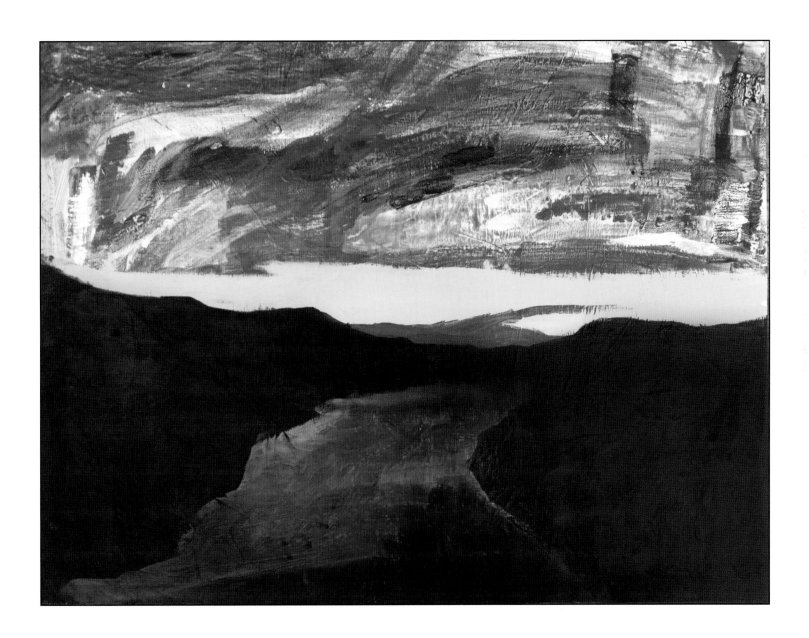

Study of Vincent van Gogh's "View of Auvers, 1890" by Christina Remson

Christina Remson's biographical note is on page 124.

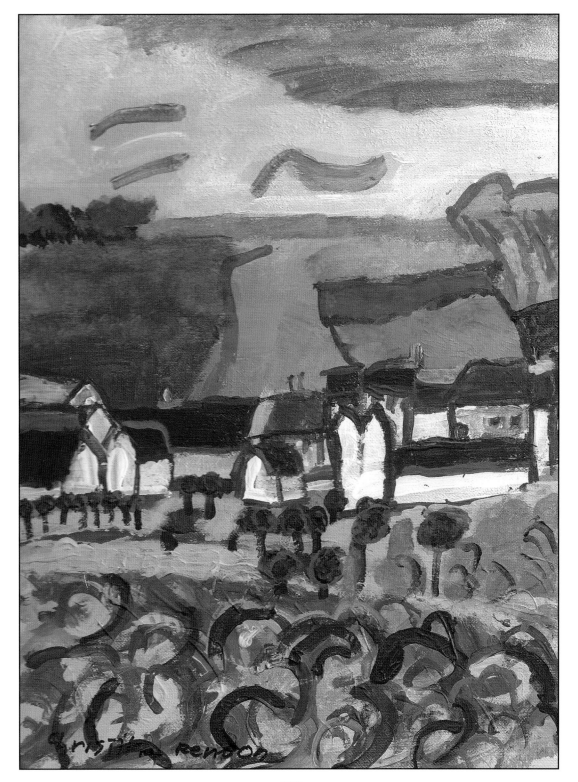

The Homework Room by Andrea Sharp

Andrea Sharp's biographical note is on page 24.

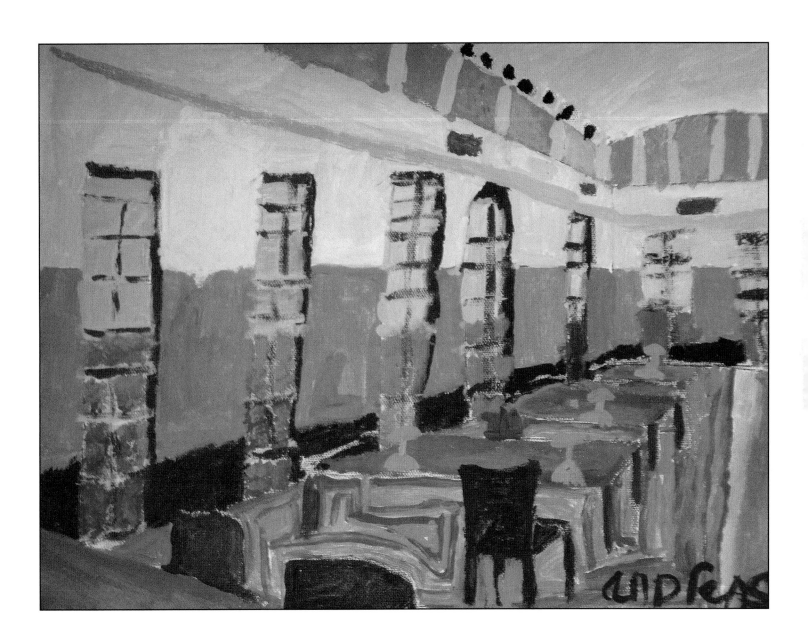

Laguna Madre by Wendy Weisz

Wendy Weisz's biographical note is on page 92.

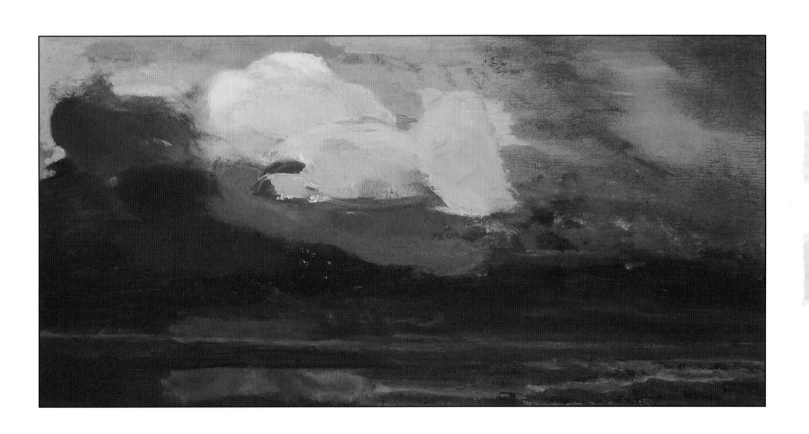

Wendy Weisz's biographical note is on page 92.

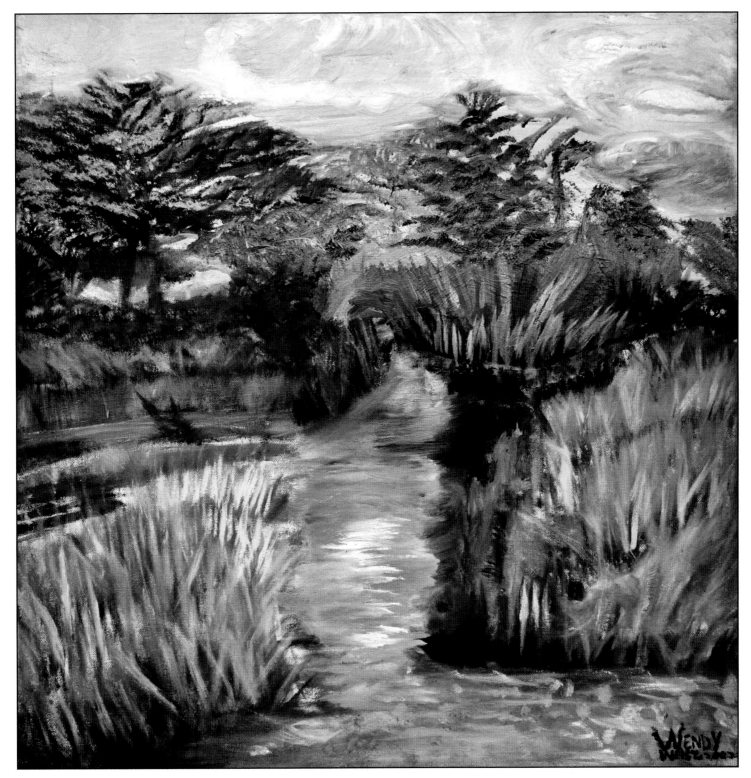

Debbie Chandler's biographical note is on page 132.

The Race Toward Normal
Debbie Chandler

I push so hard to be with the leader of the pack. I push and strain to be in the group that is behind the leader of the pack.

The feeling of being one of them urges me on. All of my problems of being different would go away. I'd be one of them. I'd be like them. We would laugh together and party together.

There would be no taunting and certainly no more whispering behind my back. The feeling of oneness would block out the past. "You're no different," I say to myself. "I'm like everyone else," I say to myself. The gap widens. Fatigue slows me down. Stopping to rest, I look ahead at the group in the distance. I am alone, alone but unique.

Connor's poem/lyric set "December Dream" is a spontaneous creation from December 2011, inspired by a journal-keeping assignment in his senior year Literature & Composition class.

Connor R. Long's full biographical note is on page 154.

December Dream

Connor R. Long

I remembered to keep quiet
I went upstairs, then I
went outside, to find
I came to a store to
buy Christmas clothes
for my family too
and I came back
to say: "Merry Christmas
for all"
then I waked up
once more

I never got the chance
all I did, is nothing
then I had a December Dream

I remembered to keep quiet
I went upstairs, then I
went outside, to find
I came to a restaurant
to order Christmas food
but, I was not in the mood

then, I went to a store
to buy cell phones and I
came back to say "Happy
Christmas to all" then I
came back with food
and I waked up once more

I never got the chance
all that I did, is nothing
then I had, had a December Dream

I remembered to keep quiet
I went upstairs, then I
went outside, to find
It was shining
when the sun was up
but I never got the chance
to shine, and when I got
back to you, all you said was
"thank you" but I just
remembered to find you
all you said to me was "I love you"
I never got the chance
to hold you, but I love you too
then I waked up once more

I remembered that I love you
You came back to me
I loved forever more
You entered my life
We had a great Christmas
so, Santa said "Merry Christmas
to all and good night"
We opened our gifts
I never got the chance
to hold you, but I love you too
then I waked up once more

I never, never got the chance
all that I did, did is nothing
then I had, I had a December
Dream once more

Allison Stokes, age 19, is a Maryland resident who is currently attending college at Penn State Mont Alto. The recipient of a Down Syndrome Footprint scholarship, as well as several scholarship awards from Penn State, she is majoring in Human Development and Family Studies. Allison aspires to work in a job where she can help people who are facing adversity.

Allison was an honor roll student in high school, where she enjoyed being a part of the drama club, the National Honor Society, and the Key Club. She graduated from Watkins Mill High School with a regular diploma in 2011. She has been on the Dean's List several times in college.

In her spare time, Allison enjoys playing badminton in her backyard, taking the family cat out for walks, watching science fiction shows such as *Star Trek, Quantum Leap,* and *Doctor Who,* and brainstorming story ideas for novels and television series. She also volunteers in her community, working with both children and retirees.

Night Worries
Allison Stokes

As I look out
my window in the night,
I ask myself,
"Why does life have to go by
so fast?"
It's rather scary.
No matter how hard
I try to live in the present,
I can't
help but wonder
what the future
has in store for me.
Will I be able to overcome
all the challenges that come my way?
What if I can't?
What if I fail?
Every night, before I fall asleep,
these worries gnaw at me
like a panther.
They claw at my thoughts
and
bite through my soul.
If only I had
a gun to shoot them
all away.

Henry and Ethan
(A Short Story for Children)

Allison Stokes

Children were laughing, the birds were singing, and there were no clouds in the sky at the park today. It was a perfect day, but not everyone was enjoying it.

"Hey, stupid! You're supposed to swing across the monkey bars, not hang from them like an idiot!" yelled a 10-year-old boy named Ethan Phillips.

"I'm not an idiot!" yelled a 9-year-old boy named Henry Rogers, who was hanging from the monkey bars like Ethan said.

"Then keep swinging," said Ethan. "Or are you too scared? I bet you're going to fall on your face."

"I'm not scared, and I am not going to fall," Henry said. However, his hands were starting to slip. Before he could save himself, he fell to the ground just like Ethan said he would.

"See? I told you so," said Ethan. "You're just a big baby. I can do that without any trouble at all." Then he kicked Henry before laughing and running away.

"I hate you!" Henry shouted in tears. He ran over to his mom, who was sitting on a bench and talking with a friend. "Mom, I want to go home now."

"What's the matter?" his mom asked.

"Ethan Phillips was mean to me again," Henry said sadly.

"I'm sorry, sweetie. Do you want some lunch? I'll make you any kind of sandwich you want."

"I'd like that," said Henry.

Then, Henry's mom put her hand on his shoulder, and the two of them went home for lunch.

The next day, Henry was walking home from baseball practice when he heard something. The noise sounded like a cat, and it was coming from a rose bush. Henry looked inside the bush, and found a little orange kitty. "What are you doing here? Are you lost?" Henry picked up the cat, and saw a tag on it with an address. "Did you run away from your owners? You look scared. But don't worry. I'll take you back to them."

The tag said that the cat was from 5503 Apple Drive, which was in the same neighborhood Henry lived in. Henry wanted to help the cat, so instead of going home, he looked for the kitty's house. After finally finding the correct house, Henry rang the doorbell. Soon, a boy with short blonde hair and brown eyes opened the door. It was Ethan Phillips!

"What do you want, stupid?" asked Ethan.

"What are you doing here, Ethan?" Henry asked.

"What does it look like, dummy? I live here," Ethan said.

Henry frowned. "I didn't know you lived here."

"Of course you didn't," said Ethan. "You only have half a brain."

"I do not!" yelled Henry. He began to wish that he didn't have to return the kitty to Ethan.

"Why don't you go home, you big baby?"

"I can't," Henry said. "I have something for you." He handed the cat to Ethan.

"Whiskers!" said Ethan with joy. "I was looking all over for you." Seeing Henry look at him, Ethan quickly said, "I mean, don't run away again, or you'll be in big trouble, mister."

Soon, Mrs. Phillips came to the door. "Why, hello, Henry. I thought I heard the doorbell ring. What are you doing here?"

"I came to return your cat."

"Thank you very much, Henry. That is so sweet of you." Mrs. Phillips smiled.

"You're welcome," Henry said.

"Why don't you come in?" asked Mrs. Phillips. "You can have some cookies, and you can meet Max. He's Ethan's little brother."

"Thanks. That would be great!" Henry said, walking into the living room.

"I have an idea," said Mrs. Phillips. "While I get the cookies and some drinks, why don't you and Ethan help Max learn his ABCs?"

"I can do that," Henry said. "I can say the entire alphabet backwards!"

"That's great! I'll be back," Mrs. Phillips said.

After she left, Henry wrote a large A on Max's whiteboard. "What letter is this, Max?" asked Henry.

After thinking about it for a while, Max said, "It's an A."

"Very good," Henry said. "Now, try another one." He then wrote a small b on the whiteboard. "Which letter is this?"

After thinking some more, Max said, "I don't know. What letter is that, Ethan?"

"Me?" asked Ethan, a little surprised. Ethan looked at the small b for a very long time. Finally, he said, "It's a d."

"No, it's not a d, it's a b," Henry said. "Stop goofing around." Then, he made a small d on the whiteboard. "What about this one?"

"I don't know that one either," Max said. "Do you know that one, Ethan?"

Ethan looked at the whiteboard for a long time again, and then said, "It's a b."

"I said stop goofing around," Henry said.

"Shut up! You're the stupid one, not me!" yelled Ethan. Suddenly, he ran into his room and slammed the door.

Henry didn't know what was wrong, so he went over to Ethan's room and knocked on the door. "Ethan, what's the matter?" he asked.

"It's nothing. I'm just not good at reading," Ethan said.

"Why is that?"

For a while, Ethan didn't say anything, but eventually he said, "My mom says it's because I have dyslexia. She says that it means I'm not stupid, but I don't read like everyone else because my brain works differently."

"Is that why you're so mean to other people?" Henry asked. "Are you mad that they can read better than you?"

Ethan was quiet, and then said, "I guess you're right. I don't think it's fair. I shouldn't have to be nice to other people if all they do is laugh and make fun of me."

"I wouldn't make fun of you or laugh at you," Henry said. "I wouldn't like it if people were mean to me because I couldn't do something. Hey, can I come in?"

"The door is unlocked," said Ethan.

When Henry opened the door, he saw a large drum set right next to the bed where Ethan was lying down. "Wow! That's a cool drum set!" Henry exclaimed.

"My parents gave it to me for my birthday last year," Ethan said.

"Are you any good?"

"Are you kidding? Let me show you how it's done." Ethan grabbed his drum sticks and started playing the drums like he was a rock star.

Henry couldn't believe what he was hearing. "That was amazing! You sound like a real professional."

"It's my dream to become a famous drummer in a band someday," Ethan said.

"I bet you will. You sound really great!" Henry grinned. "Hey, Ethan. Even though you have trouble reading, you can play the drums better than any other kid in school!"

Ethan smiled. "You're right. There are some things I can do better than others. Thanks, Henry. I'm glad you stopped by today."

Just then, Mrs. Phillips came in and said, "I was looking for you two. Your cookies and drinks are ready."

After a snack with Max and Ethan, Henry went home.

The next day, he went to the park again. Once again, Henry was hanging from the monkey bars, feeling nervous.

Suddenly somebody called out, "Just reach out and grab the next bar. It's not that scary."

"Oh hi, Ethan," Henry said.

"If you believe in yourself, you can do it. I think you can make it if you try," Ethan said encouragingly.

Hearing Ethan support him, Henry held the bar tighter, and with all the strength he had, he grabbed the next bar. Feeling more confident, he used his strength to reach the next bar and the next bar. Before he realized it, Henry had crossed all the monkey bars.

"You did it!" Ethan cried happily.

"Wow, I sure did!" Henry said. "And some day, you'll become a famous drummer if you believe in yourself and try hard."

Ethan smiled, and Henry smiled right back at him.

Ryan Teed is 25 years old. He is the fourth of five children and lives in Bloomington, Minnesota, near the Mall of America, where he likes to shop for his collection of rock t-shirts. In addition to writing poetry, he likes bowling, playing softball, powerlifting, taking care of his two cats, and singing.

Ryan hopes to start his own rock band some day. He tried out for *American Idol* in Orlando, Florida, and auditioned for two producers who said to keep practicing and try again! He also loves art and takes art therapy classes.

Sympathy of the Falling Ghost

Ryan Teed

In the pathway of dark souls

and in the woods of shadows

that makes the woods so dark

You can't see the ground
 it's foggy out at nighttime

And the woods
 is the pathway of dark souls

Until the crow calls you
 to climb on the hollow tree
in the pathway gates of dark woods.

Andrew Alistair Weatherly, age 20, is a 2012 graduate of the Riverview School, where he was the Senior Class Secretary and also one of the photographers for the prom video. Andrew's love of music and writing kept him active in chorus and inspired him to write the end-of-the-year school song for the spring concert.

Andrew has been active in horseback riding since he was a small child, and believes that horses have taught him a lot. Horses inspire him in writing his poetry, and he has written a number of poems about his horse, Dean. Besides creative writing, he also enjoys photography because he loves sharing his photo magic with a wide range of people. Andrew's other interests include singing, playing his guitar and bass, participating in track and field, swimming and surfing in the ocean, and traveling.

In the future, Andrew hopes to attend college and study mass communications. Ultimately, he could like to become a radio announcer and a news reporter.

Dream in Silence

Andrew Alistair Weatherly

Dearest Margaret,

Memories in the stream
In broad sunlight you shine,
just like the sun in the morning
when it falls upon the trees.
The shrubs sway with the breeze,
hopes will stay in bleak stillness.

The calming of the heather
and the earth in gentle rain,
the autumn through the hot burning summer;
You are still in my heart.

Now to say I'm nothing but a dreamer
reaching to the top;
After all these years was all a lesson.
Nothing changes, but so far away.

At night sleeping in the meadow in the dew
underneath the stars,
When heaven called you had to go, which brought
tears to loved ones' eyes.
Milestones will always be recalled, which leaves
You living in the sky.

Love, Andrew

Soldiers in the Fields

Andrew Alistair Weatherly

Soldiers in the fields go off to war
and then come back
and they enter the shadows
in the sun.

Flowers are blooming in the lands so
tender and mild.

Spring is popping up.

The wives go out to see
the colors of the spring.
They saw the wonders of their gardens
just before the call to war.

And when the soldiers came home, they
lay in the shadow once again holding the
ends of the earth in their hearts.

James Durbin Mask by Marissa Erickson

Marissa Erickson's biographical note is on page 6.

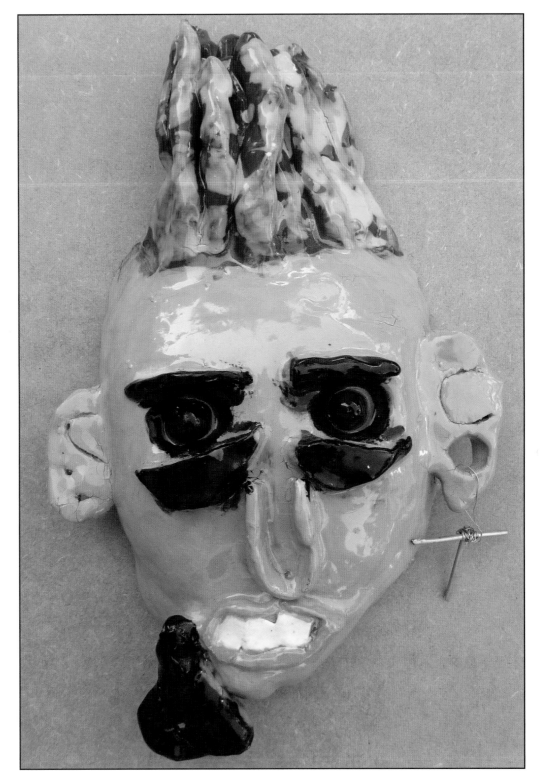

Brown Water Vase by Evan I. Johnson

Evan I. Johnson is also known as "Iceman." He is a seventeen-year-old junior at Atlantic Community High School in Delray Beach, Florida. At Atlantic High School, he is in his third year of JROTC and his second year of band, where he excels on the drums.

Evan goes to St. John Missionary Baptist Church in Boynton Beach, Florida and sings in the choir there on the third Sunday of the month. He plays two sports—basketball with High Five Basketball and soccer with Sabor—both in Boca Raton. He is looking forward to playing soccer on the Florida Atlantic University (FAU) campus this year.

When Evan finishes high school, he hopes to go to college in New York. He would also like to work at Subway and get his own apartment. At present, though, he lives with his mother and his sister in Florida (his father died in 2009).

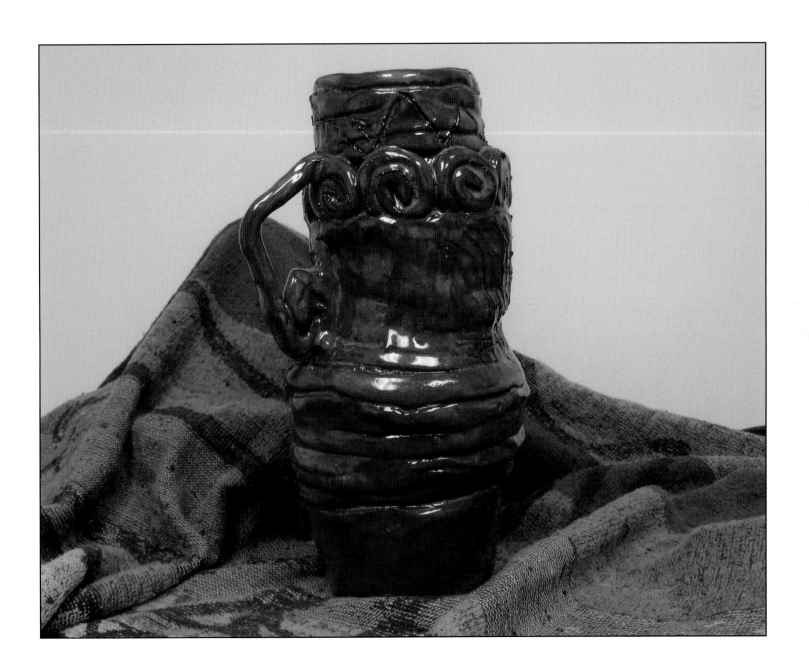

Taylor Patrick Peters's biographical note is on page 80.

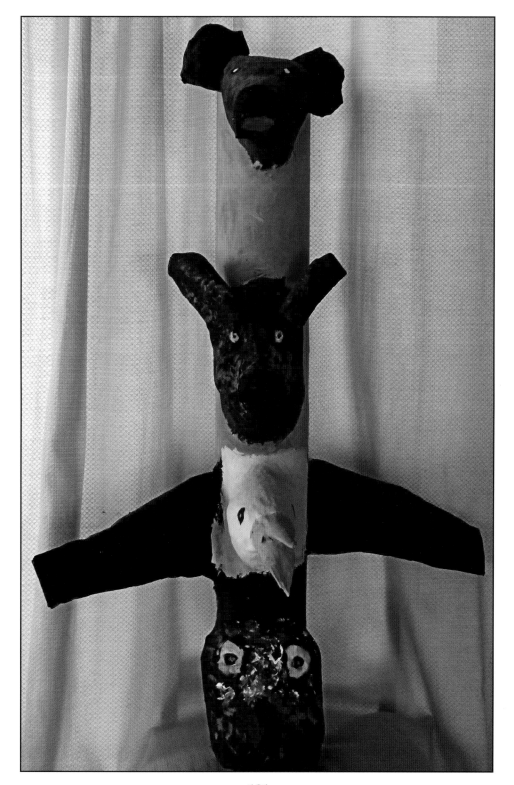

Mallard Duck by Eliza Schaaf

Eliza Schaaf's biographical note is on page 82.

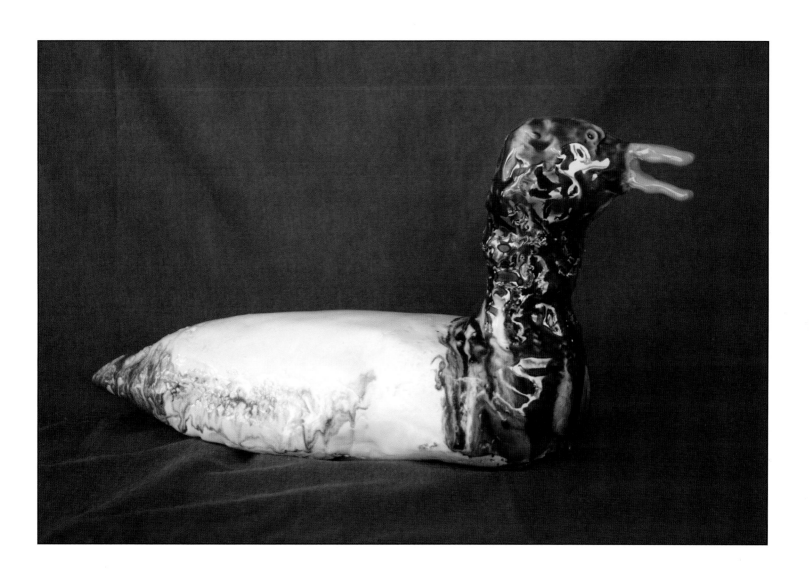

Jessica Speaks, 20, attends Valley View High School in Jonesboro, Arkansas. She credits her twin sister, Jennifer, with introducing her to art and encouraging her to give it a try. Jessica has taken three years of art class at Valley View and enjoys making abstract art the most.

A self-professed "girly girl," Jessica loves to get her hair and nails done. She also loves school—especially the teachers and the dances there. Jessica is a Special Olympics swimmer and plays an active role in the annual Buddy Walk sponsored by the Down Syndrome Association of Northeast Arkansas, Inc. Her other interests include watching movies, bowling, computer games, and playing Wii games with friends.

My Heart Box by Jessica Speaks

Jessica Speaks's biographical note is on page 194.

Tree by Jessica Speaks

Jessica Speaks's biographical note is on page 194.

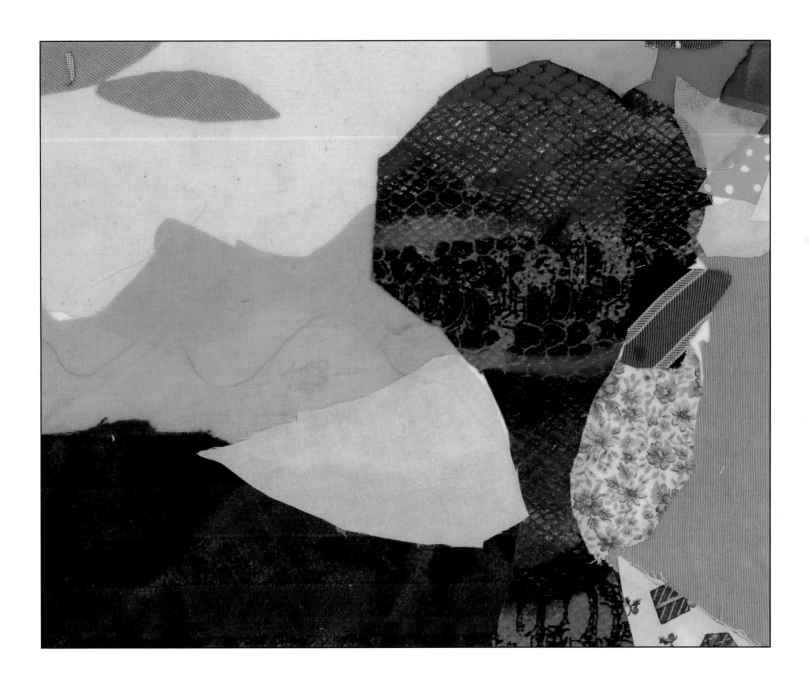

Kristin Brianna (Kristie-Belle) **Waidner,** 21, started crocheting when she was 10 years old. In high school, she learned how to use a knitting loom. She is now learning how to knit using knitting needles, which is a little bit harder. She would like to knit scarves for charity organizations.

Kristin graduated from high school a couple years ago and now volunteers two days a week at her City Resource Center. In her spare time, she enjoys playing Nintendo DS video games, Facebook, and watching the Disney Channel. She lives with her parents, her sister, and her dog in La Mirada, California.

Adrian Drower's biographical note is on page 100.

No Longer Deferred

Adrian Drower

Wait no longer - for your Dream,
Go ahead and accomplish it.
It is now time to fulfill,
Your Dream - No Longer Deferred.

It's not pitched like garbage
or erased like pencil on paper.
You can see it clearly now,
Let this Dream be your guide.

Everyone has a Dream,
Is it Deferred or not?
That choice belongs to us.
Make that Dream a reality.

A withered flower can grow back,
More beautiful than ever.
Dreams like pine trees last forever.
Your heart is key - follow your Dreams.

Wait no longer - for your Dream,
You can do anything.
Your Dream is your own,
Your Dream - No Longer Deferred.

Julie Yeager, 24, is a lifelong resident of Petaluma, California. She attended neighborhood schools from kindergarten until high school graduation in a full inclusion program. Now that Julie is an adult, she lives independently in an apartment near the downtown area of her home town. She often walks to the movie theater, fitness club, her bank, and to the cafes where she writes poetry.

After working for a few years, Julie decided to try something new and follow her passions. At her day program, "Alchemia," she takes classes in writing, acting, singing, and dancing. She also enjoys performing in community musical theatre productions. She does poetry readings and speaks to junior college students about her life as an independent person with Down syndrome.

Julie has three best girlfriends to hang out with, and a travel group called "The Funseekers." Julie's dream is to become a famous, published poet, and to open a gluten-free bakery.

Again and Again
Julie Yeager

Anything goes
Just believe that anything can happen
For a reason or nothing at all

Do not take advice
Have a mind that will be in use of oneself

Unless the timing is right
Don't think it is any night
To do anything to regret
Later in life

Hard to make a choice that will follow
For the rest of life

Study again and again
'Til someday, another dream can be clear

Maybe, just maybe
Find what to look for
In the search for happiness

Closer

Julie Yeager

Walk, don't run
It's time to sing and dance in the rain
Falling apart when times are getting a new beginning
Closer to another night in Paris
Closing of eyelids brings a brand new day

Waking up to the sun
Having a cup of tea
Smelling the fresh air
Killing two birds with one stone
With more time to spare

Roses are red, violets are blue
Thinking of words that will be true

Speak up
Let pride find peace in the starry sky
Wait for a moment
This is the time to get closer to another faith

Don't shed another tear
Let spirit shine bright, Dear
Today will come to an end

Every moment a noise gets closer and closer
Now see it to believe it
And show the whole world, love is real
In the bottom of the heart

Fiona Morris has been writing poetry since she was nine years old. She is now 14 and attends middle school in Oregon.

Fiona and her family recently moved from a little farm in the country to a house in the city. But Fiona is still inspired by nature and the beauty of the seasons. "Poetry just flows out of me," says Fiona. She has so many poems that she has decided to start a blog (www.Fionawrites.com) so that she can more easily share them with friends and family.

When Fiona is not writing poetry on her mom's computer, she loves to go outside and play games, read and listen to poetry, ride horses, and listen to music. Her favorite poet of all time is Emily Dickinson. She wants to be a poet when she grows up.

Fading Ghost

Fiona Morris

O fading ghost, appear

I hope you are holding my heart and soul in one hand

O fading ghost

Down by my home there are smoking rods and cigars in the dusty roads

And limited, sold-out tides

Solitaire painted on the wall in my thrashing dunce room

All of my people have vanished without scars

O fading ghost

It is one old story of life following the path of death

O fading ghost

O fading ghost

INDEX

Contributors' names are in **boldface type**